Precious Cargo

PRECIOUS CARGO

California Indian Cradle Baskets and Childbirth Traditions

BRIAN BIBBY

with an essay by Craig D. Bates

Heyday Books, *Berkeley, California*
Marin Museum of the American Indian, *Novato, California*

© 2004 by Marin Museum of the American Indian

Library of Congress Cataloging in Publication Data

Bibby, Brian.
Precious cargo : California Indian cradle baskets and childbirth traditions /
Brian Bibby ; afterword by Craig D. Bates.
 p. cm.
Catalog of an exhibition held at the Marin Museum of the American
Indian.
Includes bibliographical references.
ISBN 1-890771-81-3 (pbk. : alk. paper)
 1. Indian baskets--California—Exhibitions. 2. Cradleboards—California—
Exhibitions. 3. Marin Museum of the American Indian—Exhibitions. I. Marin
Museum of the American Indian. II. Title.
E78.C2B52 2004
392.1'2'089970794--dc22 2004007248

Designed and produced by Kathleen Szawiola
On the covers: [*Front*] Family, northwestern California, ca. 1900 (photographer unknown), courtesy of
the collection of Peter Palmquist; Cradle basket by Ruby Pomona (Western Mono), courtesy of the
Marin Museum of the American Indian. [*Back*] Erika Williams with son Charley (Yokayo Pomo), Ukiah,
December 2003. Photograph by Brian Bibby

Orders, inquiries, and correspondence should be addressed to:
Heyday Books
P.O. Box 9145
Berkeley, CA 94709
510/549-3564; Fax 510/549-1889
heyday@heydaybooks.com

Precious Cargo and the documentary film made in conjunction with the exhibition are available from
the Musuem Store of the Marin Museum of the American Indian:

Marin Museum of the American Indian
2200 Novato Boulevard
P.O. Box 864
Novato, CA 94948
Telephone: (415) 897-4064
Fax: (415) 892-7804
www.marinindian.com

Printed in Thailand by Imago

10 9 8 7 6 5 4 3 2 1

DEDICATION

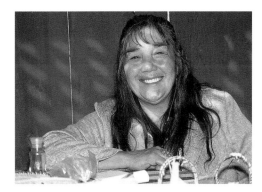

Francys Sherman, 1983
Photograph by Gayle Anita

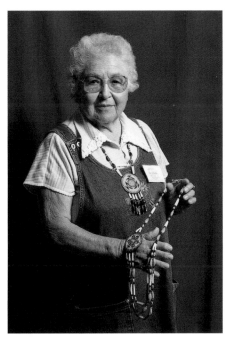

Vivien Hailstone, 2001
Photograph by Dugan Aguilar

Before *Precious Cargo* could be brought to fruition, we lost two remarkable people whose contributions to the formulation of the exhibition and catalog were of great significance. Vivien Hailstone and Francys Sherman embodied what this exhibition is all about. They had lived it.

For nearly half a century, Vivien (Risling) Hailstone was the leading advocate for traditional basket making in California. In the early 1950s, she began actively organizing classes and workshops at her home on the Hoopa Reservation, encouraging a dwindling number of traditional weavers to teach. Ahead of her time, she pioneered the ground now traveled by aspiring weavers and anyone else who has sought to maintain or resurrect traditional Native arts. Her kind, cheerful, and classy demeanor did not hinder her ability or effectiveness as a serious and powerful force in Indian education, and as an activist for Native rights on the state and national level.

Francys (Wenz) Sherman was raised among her Western Mono relatives at Northfork, in Madera County. Even in the 1920s, there were still several elder relatives who were monolingual, speaking only Nɨm, the native language of the Northfork Mono. Francys was among the last generation to travel by horseback up and over the Sierra Nevada on the old trails to visit the Owens Valley Paiute. Her life often followed the patterns of traditional Western Mono existence. She gathered seasonal foods much as her ancestors did—mushrooms, acorns, and sourberries. I recall her describing in great detail how one knows that the caterpillars are in the buckbrush, the techniques for gathering and cooking them, and the unpredictability of their seasonal arrival. She knew of these things intimately. She loved all of it—gathering food, gathering basketry materials, weaving. She was one of the happiest and most enthusiastic people I have ever known.

It is easy to think that the old days of Native tradition and lifestyle are somewhere back in the irretrievable past—a time that those of us in the present cannot experience. Then, in a conversation with someone like Vivien or Francys, they lay it in your lap. It was such a privilege to know them, to be informed and enlightened by their experiences, and to be touched by the universal goodness of their souls. They shall be deeply missed.

Contents

▼ ▼ ▼ ▼ ▼ ▼ ▼ ▼ ▼ ▼ ▼ ▼ ▼ ▼ ▼ ▼ ▼ ▼

Acknowledgments

▼ ▼ ▼ ▼ ▼ ▼ ▼ ▼ ▼ ▼ ▼ ▼ ▼ ▼ ▼ ▼ ▼ ▼ ▼ ▼

*P*recious Cargo is the result of collaborative effort involving many individuals. Assistance toward the project took many forms, but all contributed to the development of the exhibition, publication, and documentary film.

Original team members whose expertise and ideas were central in the development and direction of the exhibition include Judith Polanich, Craig D. Bates, Kathy Wallace (Yurok/Karuk), Vivien Hailstone (Yurok/Karuk/member of the Hoopa tribe), Linda Yamane (Rumsien Ohlone), and Susan Billy (Pomo).

Those who assisted with archival materials and additional research include Sherrie Smith-Ferri of the Grace Hudson Museum; Betty Smart and Sandy Taugher-McCleod of the State Museum Resource Center, California State Parks; Karen Janke-Barila of the Haggin Museum; José Rivera; J. B. Kingery; Amy Kitchener; Peter Palmquist; Terry Strauss; and Herb Puffer.

Thanks to Tom Liden for object photography, and to Ronald Johnson for the photographs on pages 19, 20, and 42. Native contributors of oral history material (in addition to the participating artists) include Rosalie Bethel (Western Mono), Richard Bugbee (Kumeyaay), Gordon Bussell (Hupa), Justin Farmer (Ipai), Uly Goode (Western Mono), Della Hern (Mono Lake Paiute/Yosemite Miwok), and Leona M. Sendldorfer (Pomo).

Project staff for the Marin Museum of the American Indian included Shirley Schaufel, Project Director; Brian Bibby, Guest Curator; Verna Smith, Museum Educator; Sylvia Lesko, Collections Management.

Lenders to the exhibition include Brian Bibby, Justin Farmer, The Haggin Museum, Albert Hailstone, and Herb Puffer.

Precious Cargo will travel throughout California under the direction of the California Exhibition Resources Alliance, Lisa Eriksen, Executive Director.

In conjunction with the *Precious Cargo* exhibition, a documentary film was produced with funds from the National Endowment for the Humanities and a contribution from the Native American Cultural Center of San Francisco. We wish to acknowledge Terry Strauss, producer/director; Michael Anderson, director of photography; Saul Rouda, sound; Theron Yeager, editor; Brian Berberich, production assistant; and Peter Coyote, narrator.

Precious Cargo has been made possible by a grant from the National Endowment for the Humanities. Any views, findings, conclusions, or recommendations expressed in this publication do not necessarily represent those of that organization. Additional support was provided by the National Endowment for the Arts; Fund for Folk Culture; California Arts Council; California Council for the Humanities; the L. J. Skaggs and Mary C. Skaggs Foundation; and the Marin Community Foundation.

Introduction

▼ ▼ ▼ ▼ ▼ ▼ ▼ ▼ ▼ ▼ ▼ ▼ ▼ ▼ ▼ ▼ ▼ ▼ ▼ ▼

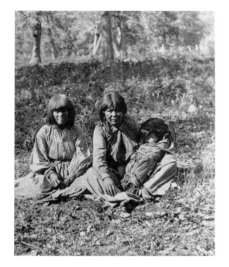

▶ Women with child in cradle, Yosemite Valley. Photograph by Edweard Muybridge, 1872, courtesy of the Hood Collection, National Park Service, Yosemite Museum. No.159/23

Although we may think of the cradles in this book simply as baskets—objects to hold and carry infants—they embody many layers of culture encompassing social structure, tribal worldview, and concepts of health, safety, and danger; the baby basket carries people's most sincere thoughts regarding the nature of life. And few events bring those thoughts to the surface, and thrust them in motion, like the birth of a child.

Precious Cargo explores the use of California Indian cradle baskets within the cultural milieu that surrounds the birth of a child, examining the form and function of the baskets themselves, and also traditional values concerning the nature of health, the phenomenon of birth and its impact on social relationships, and the prescribed roles of new parents. Also examined are the effects of history and change on cradle baskets through the last century, as they have moved from being essential utilitarian objects, to curios for sale, to symbols of ethnic identity in a multicultural society. The personal perspectives and experiences of living cradle makers reveal critical nuances and meaning embedded in the cradle. In all, twenty-three tribal traditions are represented, illustrating the remarkable diversity of California Indian cultures.

By pulling from a variety of disciplines and examining interrelated issues of fertility, birth, family, community, and health, *Precious Cargo* seeks to present a holistic view of the different Native traditions as they relate to the design and use of cradle baskets.

► *Historical Overview*

The continuity of Native traditions in California—in some cases their revival—has occurred against great odds, in the face of significant adversity. In order to truly appreciate their survival, within California or elsewhere, whether focused on baby baskets or any other aspect of culture, one may need to view these traditions against the backdrop of history.

Native California was once perhaps the most linguistically and culturally diverse region in North America. Several hundred autonomous communities speaking an estimated 64 to 80 mutually unintelligible languages made their homes within the present political boundaries of California. Numbering approximately 300,000 people, they constituted perhaps the greatest population density in North America and maintained relatively stable and successful ways of living over a long period of time in a broad range of environments.[1]

Food collecting strategies among Native Californians involved a variety of baskets, with construction and design characteristics developed to meet specific needs. Baskets were used in all areas of the food quest, and the diversity of Native basketry traditions mirrors the ethnic and environmental complexity of the region.

The settlement of California by non-Natives greatly disrupted the lives of the indigenous people. By the late eighteenth century, Franciscan missionaries along the central and southern California coast were conscripting and separating members of Native families. The damage to traditional family life led to breakdowns in tribal social structure.

Young and unmarried Native women were kept under lock and key in the mission *monjerios* after the workday was complete. The health conditions that resulted from poor sanitation inside the *monjerios* are thought to have contributed to heavy loss of life among women of child-bearing age. Combined with the ongoing conversion and Hispanization of Native residents within the missions, this clearly had an effect on the transmission of Native culture. The rebozo, a blanket-wrap used to carry infants throughout much of Mexico, appears to have largely replaced locally made cradles. This is evidenced today by the scarcity in museum collections of cradles from this region of California.

While Native populations in northern California lived, for the most part, beyond the reach of the Franciscan missions, their lives were greatly impacted by the arrival of Euro-Americans in the mid-nineteenth century. A devastating epidemic swept through the entire Sacramento Valley in 1833. Estimates of the mortality rate from the epidemic run as high as 75 percent for some regions.[2] Fifteen

years later, the discovery of gold near Coloma precipitated one of the largest and swiftest migrations in American history. This mass influx was equally devastating to the Native population and the environment. It was also brutal.

In addition to the tremendous depopulation that resulted from introduced diseases, starvation, and the episodes of brutality that accompanied the gold rush and its aftermath, Native societies suffered the fragmentation and demoralization of the social, religious, and cultural foundations that had held them together for centuries. By 1900, the California Indian population had shrunk by a staggering 93 percent from the estimated pre-contact (ca.1542) level. An immeasurable amount of human knowledge, oral literature, whole languages, music, pharmacology, and perspectives on life unique to this corner of the planet had also disappeared.

▶ A Necessary Thing

By the latter half of the nineteenth century, as Native hunting and gathering cultures adapted to a cash economy in California, the weaving of cooking baskets and others connected to the quest for food had begun to ebb, although there were weavers who continued to make them, largely for sale to collectors in the period from about 1890 to 1920. Seed gathering was no longer essential to survival, so there was little need for tightly woven burden baskets, seed beaters, or winnowing baskets. The need for a hopper-mortar basket, used in conjunction with the pounding of acorns in a stone mortar, was largely eliminated by the availability of commercial corn grinders. Baskets for sifting acorn flour or stone-boiling acorn soup were no longer needed.

There are numerous reasons for each change, and certain practices have survived in some areas longer than others. For example, basket caps and Jump Dance baskets continue to be used within a ceremonial context among the Hupa, Yurok, Karuk, Tolowa, and other communities in northwestern California, and baskets are occasionally used

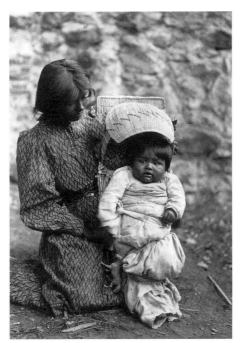

▶ Lena Brown and son, Virgil (Sierra Miwok), Yosemite Valley. Photograph by Julius T. Boysen, ca.1902, courtesy of the Southwest Museum. No. 22091

Here Lena Brown uses a cradle obtained from the Mono Lake Paiute, a neighboring tribe who frequented Yosemite Valley, as did the Sierra Miwok. Note the toy horse attached to the lower side of the cradle, and the design of diagonal lines on the cradle hood, symbolic of a male occupant.

in cultural demonstrations, but most traditional forms of basketry associated with the hunting and gathering lifestyle have become obsolete.

Notwithstanding all that, there is one aspect of life in Native California that has not changed: people still have babies. As a result, making baby baskets has remained a very functional pursuit. A highly effective child-care tool, they were never fully abandoned by the faithful. In communities where baby-basket traditions have remained constant, cradles are not artifacts or art objects, but rather baskets that people have made with full intentions of using them.

▶ Form

The diverse environments of California were reflected in the cultural diversity of the Native people. Cradle basket forms, techniques, and materials exemplify this diversity. They illustrate different paths seeking to address a universal issue.

Like other baskets, the cradle basket was invented to solve a problem. Two essential features of a cradle's design are that it must be strong—a safe and comfortable place to put a baby—and yet light enough to be portable. The materials chosen to make a cradle were based on the qualities of strength and flexibility, and their selection has become ingrained as regional tribal tradition. Choice of the right material may occasionally be articulated in myth and reveal the critical nature of making the proper selection:

▶ Weaving materials for cradle basket (Sierra Miwok): coils of split shoots, metal paring knife, piece of glass for scraping willow shoots, lard bucket for holding water, commercial yarn, metal awl, bundles of willow shoots. Photograph courtesy of Marin Museum of the American Indian

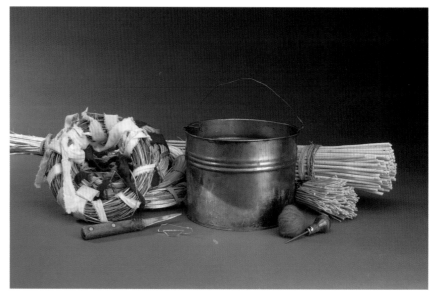

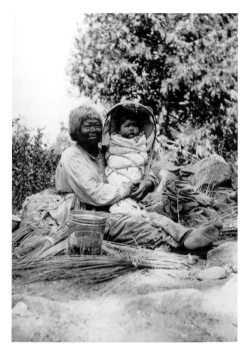

▶ Lucy Brown (Miwok) and
great-granddaughter Alice
Roosevelt Wilson (Miwok/
Chukchansi) in Yosemite.
Photograph by J. T. Boysen,
ca. 1903, courtesy of National
Park Service, Yosemite
Museum. No. 8703

Right:
▶ Tina Charlie weaving cradle
hood, near Mono Lake. Photo-
graph by C. Hart Merriam,
1937, courtesy of Bancroft
Library. No. 1978.8.378.P14

Long ago Quail used to make cradles out of sandbar willow. but all her infants died. She
wondered why her children died. Then she stopped using sandbar willow, and instead
used red willow and arroyo willow out of which to make cradles. The children didn't
die any more."[3]

Out of the fascinating and sometimes puzzling variety of cradle forms that
emerged in indigenous California, there appear to be three fairly distinct types—
all, however, with varying details. There is the sitting cradle, constructed so that
the infant sits in a seat formed by the base of the basket (see pages 33–59). There
are at least three variations of the sitting cradle, which appears throughout north-
western and northeastern California, as well as among the Pomo, Yuki, and Win-
tun. These cradles sometimes include hoods or visors, or a substantial protective
hoop.

Next, there is the rectangular lie-in cradle with hood. The baby lies on its back
in this cradle (see pages 61–88). They are made with closely woven vertical rods
and sometimes overlaying horizontal warp rods. This style includes an attached
hood and appears throughout eastern California among the Paiute, Shoshone,

and Washoe, and west of the Sierra Nevada among the Western Mono and Southern Sierra Miwok as well as the Chukchansi and other foothill Yokuts groups.

A third style, with several variant forms, might be referred to as "ladder-back," consisting of somewhat larger rods or crossbars arranged horizontally onto one of three types of frames: a pair of vertical rods (like a ladder); a hairpin-shaped frame; or a Y-like fork (see pages 89–109). Some include hoods, with forms and techniques varying greatly. The child lies on its back on this type of cradle as well. The geographic distribution of this style covers much of the length and breadth of the state, from the Mohave of the Colorado River, to the Chumash on the Pacific coast, to the Yokuts of the interior San Joaquin Valley, to the Miwok and Maidu of the Sierra Nevada.

A major goal of *Precious Cargo* is to encourage viewers and readers to look beyond the obvious. To help illustrate the unseen aspects of culture that precede and surround the baby in the cradle, several rarely interpreted objects are also included: for example, an ordinary utility tray anointed with herbal steam, over which powerful ritual formulas have been recited, is transformed into a receiving cradle.

In addition to its role in physical growth and posture, the cradle is believed to influence the child's psychological and social development. Infused and adorned with symbolic objects—ideas tied to baskets—the cradle wards off intangible dangers and the catastrophic possibilities that lurk before, during, and after the trauma of childbirth. It is the framework, physically and metaphysically, for the journey through infancy, carrying with it a host of procedures, observances, and associated objects involved in the journey.

Imbued with values that reflect the tribal worldview, the cradle basket acquires both functional and symbolic roles. Traditionally, the relationship of the cradle maker to the infant and the ritual exchange of baskets and other property reinforced social structure, often set within a mythic context. Intended as a gift of love to the newborn and its family, a cradle basket solidifies familial relationships, providing definition and orientation to the occupant's identity. Within a Native community, the baby basket is an immediately recognizable expression of group affiliation, or membership. Holistically, the cradle is a "person molding" thing: a container, a metaphor, a vehicle for thoughts, values, relationships, hope, and prayer.

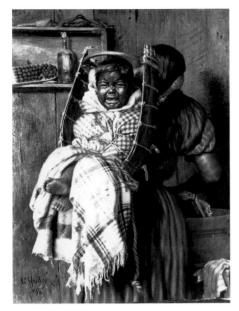

▶ *Blue Monday,* oil painting by Grace Carpenter Hudson, 1896. Photograph courtesy of the Grace Hudson Museum and Sun House, City of Ukiah. No. 3066

A Pomo woman does the wash with her baby in its cradle. This may have been a familiar scene to the artist, as Pomo women worked in the Hudson family household.

Right:

▶ Eleanor Sell (Crooks) in Paiute cradle, Yosemite Valley, ca.1900 (photographer unknown), courtesy of National Park Service, Yosemite Museum. No. 28451

The Sells were a non-Indian family living in Yosemite Valley

▶ *Function*

When traveling to gather acorns, grass seeds, clover, or basketry materials, women needed to be able to transport their babies safely and care for them. There are few early written accounts of how women went about this. One account from a Konkow elder spoke of women pulling mustard (greens) from fields in Round Valley with babies on their backs.[4] An early pioneer to California, J. J. F. Haine, who visited the village of Yupu at Marysville in December 1850, observed of Indians in general that "the Indian woman, while doing all the work of the family, when she has a baby always keeps it suspended from her back, wrapped in a kind of basket. Often there is a parasol to protect the papooses from the sun. The baby is attached upright in his suspended cradle, so that he cannot move either his arms or his feet at all . . . He seldom makes the usual and very unpleasant music of the white babies. As to the mother, she seems unaware of her precious burden."[5] Indeed, in hunting and gathering cultures throughout the world, it is not uncommon for women to perform everyday tasks with babies on their backs.

The usefulness of Native cradles has not been lost on non-Indian customers. A young couple touring Yosemite National Park in 1908 decided to contract with Old Lucy (i.e. Lucy Brown—see photo, page 5) to make them a cradle. Just three days later, and at a price of three and a half dollars, the Anthonys owned a baby basket:

It proved to be the most handy, useful thing we could have had—the only possible way in which one can carry a child with safety and have free use of the hands.[6]

The cradle and its occupant could be tied to a tree trunk, leaned against the side of a house or rock, suspended from the back of a chair, or, with some cradle forms, stuck upright into the ground. The baby was very often upright and able to observe what parents and others were doing, promoting a sense of inclusion. The child was often at eye level with parents rather than lying down, isolated in a crib. Native elders have commented on this and feel it was an important factor in the child's socialization. In short, the children were rarely left behind. "They didn't have baby sitters," remarks Western Mono cradle maker Leona Chepo. "They took their babies everywhere."[7]

When asked how the use of cradles has changed during their lifetime (ca.1915 to 2000), elders mentioned that one of the most noticeable changes was that women no longer carry cradles on their backs by way of a tumpline across the forehead or shoulders. In the Northfork area (Western Mono), this was still a common method throughout the 1930s. Western Mono elder Rosalie Bethel, who carried her own children in this manner, explained:

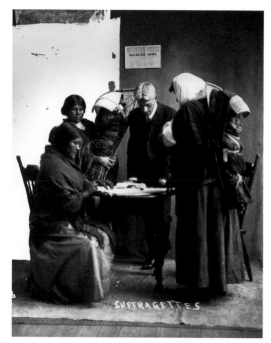

▶ Owens Valley Paiute women registering to vote (*left to right:* Amy Yandell, Susie Kane, Mr. Von Blon, and Emma Willis). Photograph by Andrew Forbes, 1916, courtesy of the Los Angeles County Museum Of Natural History. No. 5396

When we carry it we usually have a strap in back . . . the strap goes around our head, and the baby lays on your back—like when we're traveling, going out to gather something, or go for a distance. That way it leaves both hands free.[8]

Paiute families were crossing the Sierra Nevada on horseback into Yosemite Valley with babies in cradles during the 1920s. The cradle was sometimes secured to the saddle horn. As access to automobiles grew, people drove more and walked less. Babies were still put in their cradles, but they were no longer carried for long distances. Packing the cradle on one's back became less necessary.

▶ *Change*

Cradle baskets represent one of the most enduring traditions in Native California, yet they have also been subject to change: evolving and transforming in style, incorporating new and exotic materials, and responding to the conditions and influences of a changing world. Change is not the antithesis of tradition, but rather part of it. History creates change. History has also affected the lives of

people who make and use cradle baskets, and they have responded in various ways to challenges to tribal tradition.

Rosalie Bethel and Vivien Risling Hailstone (Karuk/Yurok) represent one of the first generations of Native children in California to attend federal boarding schools administered by the Bureau of Indian Affairs or, as with the school Rosalie Bethel attended in Northfork, by non-Indian religious organizations. Rosalie Bethel spoke of her experience attending the Northfork Indian mission school as a child:

> Well, when I was a child, when we went to school, we were punished for speaking our language. And as I grew older I found out the reason why. They felt as though an Indian could not handle two cultures, and they wanted [us] to forget our culture and go the new man's way. And that was good thinking, [to] my way of thinking, but they didn't have to punish us for speaking our language, because when we go home we're going to, you know, we never forget. But then a lot of our younger children, they start getting ashamed of their culture. They felt as though, "My gosh, nobody accepts us." Then they turned the new man's way. Some of them then didn't put them in baby baskets [any more].[9]

Vivien Hailstone attended the federal boarding school at Hoopa, in northwestern California, as a young child. It was an experience that affected her deeply, and may well have lighted the fire of cultural pride and activism that defined much of her life.

> The biggest trauma in my life was going to boarding school, because they took us away from our parents. We couldn't go home. Because if we went home, we'd be speaking our language, or singing our songs. And I'd hear little kids crying at night. They're not supposed to, so they'd cover their faces. It was such a sad time. And to get the Indian out of you, they made us march. We marched and we marched. We marched for hours at a time.
>
> [Once] my brother-in-law was singing a drum song, him and another guy, they were drumming behind the dormitory, and they got caught. And he was strapped. If you said an Indian word they would wash your mouth out with soap. It was so bad, and I never knew why. Why was it so bad? I didn't know what we did.[10]

While some people responded to these experiences by distancing themselves from aspects of traditional Native culture such as speaking their language or making and using cradle baskets, others had the opposite response. In today's environment, where all things Indian are highly popular, it is difficult to fully appreciate the bravery of individuals like Vivien Hailstone and Rosalie Bethel. As their experiences reveal, a cradle basket is something more than a well-developed, wonderfully functional object for carrying a baby. In the bicultural, often multicultural, environment that has existed in and around Native communities in

▶ Girl with doll at Greenville Indian Mission School, ca. 1895 (photographer unknown), courtesy of the Plumas County Museum. No. 14-NP-14D

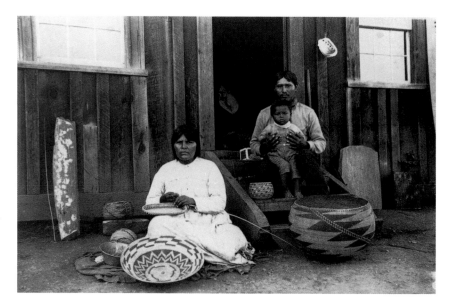

▶ Jeff Dick holding son, Billy, with wife Joseppa (Pomo), Yokayo Rancheria. Photograph by H. W. Henshaw, ca.1892, courtesy of the Grace Hudson Museum and Sun House, City of Ukiah. No. 15431

California for generations, carrying a child down the streets of Bishop or Northfork or Ukiah is a clear indication of identity. Cradle baskets are visible symbols of tribal tradition.

▶ *Living In Accord*

Aside from its functional attributes, the cradle symbolizes perhaps life's most significant moment: the miracle of birth. Viewing a cradle basket on exhibit, the observer is really only seeing one of the final chapters of a long and involved story; the making of a cradle basket is one of the last acts in a series of procedures, observances, and careful modes of living that precede the birth of a child. In traditional cultures, the actions of parents during this period involved a strong belief in reciprocal relationships, particularly with the supernatural powers influencing all aspects of life, including fertility, growth, and the gift of good health. The months preceding birth involved behavioral and lifestyle adjustments for prospective parents, and were believed to have a critical effect on the outcome. The parents' lives were enveloped with a concern and responsibility that required discipline and sacrifice. Their aim was a proper orientation for the child, enabling it to become a complete person.

The principle of sacrifice—basically, giving up something in order to receive something—is central to most of the world's religions, and it is a core belief in California Indian traditions. Sacrifice was a primary means of mediating the forces of the spirit world that exists parallel to our immediate environment. This concept

was evident in the prenatal and postpartum observances of the prospective parents. Mothers-to-be adhered to specific food taboos, as did their husbands. Living correctly, in accordance with culturally defined standards of behavior, following a proven road of success, negotiating the sensitive and potentially dangerous space before them, prospective parents sought to ensure a successful birth and healthy child.

As new parents, a couple had to know the rules for living in the world. And most of the time, this meant making sacrifices, whether in the form of diet or personal freedom. All of this underscores a prevailing belief in maintaining reciprocal relationships: with people, animals, food crops, and most importantly, the supernatural forces that influence all aspects of life in the world.

Some examples from the Pomo people of north-central California and others illustrate the multitude of childbirth traditions that sprang from Native cultures.

Long ago, as now, a woman might have difficulty conceiving. In certain parts of the California countryside there are large, sometimes peculiarly shaped boulders, shrines that are said to contain within them the power to grant fecundity to women who follow the appropriate procedures at the site. Such shrines often represented mythic figures, commemorating events of the distant past. In this light, birth moves from being a purely natural biological event to a phenomenon inspired, at least in part, by supernatural means.

"A woman can't get children simply by having sexual intercourse. She must do something else besides," stated Bowen, a Northern Pomo man, in an interview with anthropologist Edwin M. Loeb.[11] Another of Loeb's informants, a Coastal Pomo, said that in former times, his people did not believe that sexual intercourse

▶ Child Rock, Knights Valley. Photograph by Samuel A. Barrett, ca. 1915, courtesy of the Phoebe Hearst Museum of Anthropology, University of California, Berkeley. No. 15-2638

Right:
▶ Child Rock, Dry Creek Valley. Photograph by Bill Smith, ca. 1977, courtesy of Sherrie Smith-Ferri. This is one of the rocks that was inundated by Lake Sonoma.

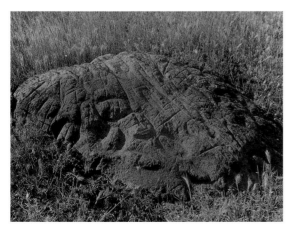

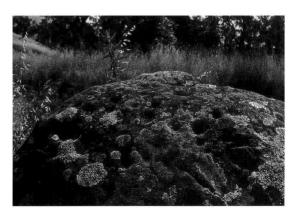

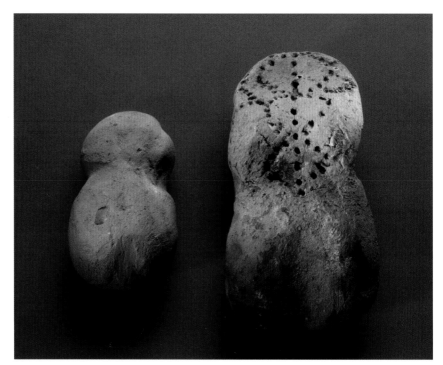

▶ Fertility Dolls, *ma'chama.* Clay. 4 in. high, 2¼ in. diameter. Marin Museum of the American Indian. Replicas of dolls collected from Old Jenny at Upper Lake by Stewart Culin in 1908, in the Brooklyn Museum collections

had anything to do with having children.[12] It seems clear from these and other statements that the miracle of childbirth was indeed something that might require supernatural or spiritual assistance. One well-known and often used ritual to assist a woman in becoming pregnant was to visit a "child rock," or *gawik.* Some sites associated with fertility represent mythic figures turned to stone eons ago. Making personal contact with these empowered places was believed to grant the pilgrim fecundity. There were several such rocks located throughout Pomo country. Each community used them in their own distinct way.

Important rituals were often linked to these natural sites. Among some Eastern Pomo, a woman fasted four days, drinking only a little water. On the fifth day she traveled alone to the *gawik.* Once there, she performed several ritual movements in a precise order. After four feigns, she cut a groove into the rock with her flint knife (among the Coastal Pomo, a straight line indicated the wish for a boy, a curved line for a girl).[13] Taking the dust she had ground from the cutting, she decorated her body with two lines from her lower lip to her navel, a horizontal line across her chest from armpit to armpit, and a circle where the horizontal and vertical lines intersected. A dab where the part of her hair began on her forehead completed the ritual markings. The woman then spoke to the rock, asking for a child. Before leaving the area, she again proceeded through several ritual movements.

Several baby rocks in the Dry Creek Valley were inundated by the waters of Lake Sonoma in 1984, following the construction of Warm Springs Dam. Others were relocated by the Army Corps of Engineers.[14] Many Pomo people feel that removing these rocks to other locations rendered them useless, as their original locations were the key to their power.

Certain springs and trees were also thought to possess the power to cure sterility. Two specific trees—a fir near Upper Lake, and a tree in Potter Valley—were identified in the early to mid-twentieth century.[15]

The *ma'chama* (earth woman) figurine is a symbol of fertility. The Pomo made these small headless dolls from local clay deposits and occasionally gave them to young women who had trouble becoming pregnant, as a potent symbol of fertility. *Ma'chama* might also be given to a newly pubescent girl, hidden away among her personal belongings, treasured as a sacred promise (*kudwoltcu*, faith or confidence expressed in the clay doll to bring children). The patterns shown on the upper bodies of the figurines are said to represent those once customary among some Pomo women.[16] The bluish clay used to make the dolls was said to be the same that Coyote used when he created the moon.

Similar dolls of clay and wood were made by the Northern Pomo. Men made them in the ceremonial house before a ceremony was to take place. The figurines themselves were normally not considered sacred; children played with them routinely. However, once the *yompta* (ceremonialist) prayed over them, the dolls became imbued with the power of fecundity. A woman hoping to give birth received

▶ John Hudson's field notes on Pomo traditions, ca.1900, courtesy of the Grace Hudson Museum and Sun House, City of Ukiah

palala bo
boye bo
hanpai bo
pulba bo

(cottontail road
jackrabbit road
quail road
dove road)

A lullaby recalled
by Betty Murray Castro
(Nisenan)

either a male or female doll, depending on her desire. She carried it around in a cradle, took it to bed with her, suckled it, and treated it like a child in every way.[17]

The creation of clay figurines in northern California has a long history, with several examples from Marin County appearing in the archaeological record.[18] It is not certain whether these tiny figurines associated with the Middle Horizon time period were used in the same manner described by Pomo people at the beginning of the twentieth century. However, their features are certainly reminiscent of later fertility dolls.

The evocation of spiritual assistance to help ensure pregnancy (and at other stages leading to birth) should not overshadow what appear to have been sound medical observances. John W. Hudson, an ethnographer of California Indian cultures at the turn of the twentieth century, was also a practicing physician living in Ukiah. He spent a great deal of time visiting his Pomo neighbors, and as a doctor, he became interested in Pomo medical concepts, procedures, and use of botanicals. Among Hudson's unpublished works is a manuscript devoted to childbirth in which he noted a number of observances practiced by Pomo women in the months and days preceding the births of their children.[19]

For example, Hudson noted an exercise called *ka-wi ko-di ba-an ka-ke bi-culcu yo-mal hun* (literally "child-easy-born-properly-by-hillside-descending"). A Pomo woman might practice strutting down a slope daily with body erect, taking jolting steps in order to ensure a normal, safe, head-first birth.

Dietary restrictions were also observed for several weeks preceding birth. As was the custom throughout most of Native California, meat and salt were forbidden to the pregnant woman. Among the Northern and Eastern Pomo, hot foods were avoided, and eating fish was also forbidden, as it was said the fish would drink up all of the liquid inside, resulting in the expectant mother's death.

▶ *Taking Precautions*

Native people viewed the first five to ten days following birth as a highly sensitive period, and the activities of both new parents were greatly restricted. New mothers avoided moonlight, sunlight, hot foods, cold water, meat, and salt. New fathers did not hunt, fish, or gamble, and they often observed the same dietary restrictions as their wives.

Among Native people throughout California, pubescent girls used scratching sticks during their isolation at the onset of menses, and new mothers used them for five to ten days following the birth of a child. During these distinct periods of time, a woman was forbidden to use her hands—particularly her fingernails—to

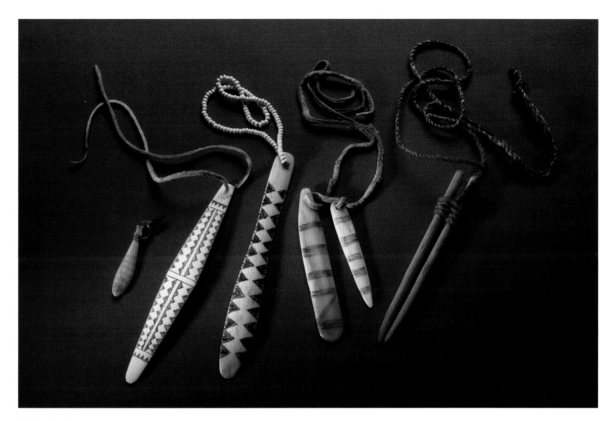

Left to Right:

▶ Scratching Stick (Yurok) ca.1890.

Mammal bone, glass bead, buckskin. 2½ in. long x ¾ in. wide. Vivien Hailstone Collection. Courtesy of Albert Hailstone. Once owned by Jane Young of the village of Kenek.

▶ Scratching Stick (Hupa) 2001. George Blake (Hupa/Yurok), 1944–

Elk antler, buckskin. 5½ in. long x 1½ in. wide. Marin Museum of the American Indian. Replica of original collected by P. H. Ray in 1885, National Museum of Natural History, Smithsonian Institution. Cat. No. 77198

▶ Scratching Stick (Northwestern California) 2001. Frank Gist (Yurok), 1950–

Elk antler, glass beads, string. 7⅝ in. long x 1 in. wide. Marin Museum of the American Indian (Replica of example attributed to northwestern California, State Museum Resource Center, California State Parks. No. 309–64–24)

▶ Scratching Sticks (Shasta) 2001. Craig Bates, 1952–

Mammal bone, buckskin a) 5 in. long x ⅞ in. wide; b) 3⅝ in. long x ⅝ in. wide. Marin Museum of the American Indian (Replica of pair collected by Roland Dixon, 1903, American Museum of Natural History, New York, No. 50–4070)

▶ Scratching Sticks (Miwok) 2001. Craig Bates, 1952–

Willow, red earth pigment, milkweed cordage. 6 ¼ in. long x ¾ in. wide. Marin Museum of the American Indian (Replica of pair collected from Renaldin Reed (Miwok) by C. P. Wilcomb at Bald Rock, Tuolumne County, 1914, Museum Fur Volkerkunde, Berlin, Germany, No. IV.B.12288)

scratch herself or comb or part her hair. The central reason for using a scratching stick involved cleanliness, and the need to be free from any contamination. The presence of blood during the birthing process, as with menses, was a primary concern. The sticks were usually attached to a string or thong and either looped around the wrist or suspended from the neck.

In northwestern California, these implements were often made from a split section of elk antler, given a particular shape, and embellished with an incised geometric pattern. In most other regions of California, the scratching stick was simply a modified twig. Among the Shasta, scratchers came in sets of two: the smaller specifically for use in scratching around the eyes.[20]

In some communities, new fathers used scratching sticks during the same period of time.[21] There is also evidence that, during their month-long (or more) seclusion in the dance house, young males engaged in the initiation process that brought them into the sacred dance society were also required to use scratching sticks.[22]

In addition to the examples illustrated here, the use of scratching sticks as part of pre-natal and post-partum observances has been documented among the Nisenan, Konkow, Modoc, Owens Valley Paiute, Ipai, Tipai, Kamia, Yuma, Pomo, Kato, Yuki, Sinkyone, Chimariko, Karuk, and Wiyot.

Among the Yuki, a new mother came under a number of restrictions immediately after the birth of her child. Due to the presence of blood during the birthing,

Left to right:
▶ Drinking Straw (replica). Goose quill. 4 in. long. Marin Museum of the American Indian
▶ Bow String (replica) 2001. Margaret Mathewson, 1962–. Deer sinew. 40 in. long. Marin Museum of the American Indian.

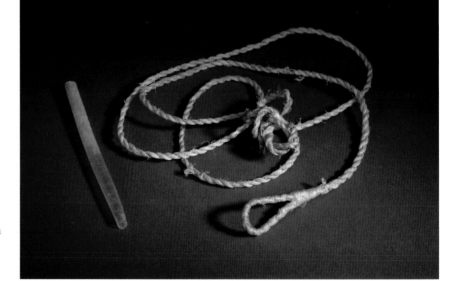

she was considered unclean, and for a period of ten days she adhered to a strict vegetable diet, ate in private, and refrained from touching most household objects. Rather than risk contaminating a cup by holding it, the new mother drank water through a straw fashioned from a hollow bird quill.[23]

Following the birth of his first child, a new father among the Northern Yana might receive a ceremonial whipping from an old hunter renowned for his luck. To bring good hunting in the future, and the freedom from hunger that would entail, the old man took the string from his bow and said, while striking the younger man from his feet upwards to his head, "I was a good hunter; I give you my luck. I was a good archer; I give you my skill."[24]

The models for such behavior are often revealed in myths. The Yana myth of Blue Jay's journey to the land of the moon is instructive in detailing the rules that apply to new fatherhood—in this case, a restriction against hunting:

> The people went off to hunt deer. "I shall walk around beside you," said Blue Jay. "My wife has given me a baby." The people went off, those people now hunted deer. But Blue Jay did not hunt deer, he just walked around with them.[25]

In another Yana myth that articulates the new father's restriction against hunting, Wildcat, a new father, cannot go hunting, but rather assists the women in collecting pine nuts: "Wildcat did not go to hunt deer, for his wife had a child. Wildcat said, 'Let us go to get pine nuts. We can do no other work now than to go to get pine nuts.'"[26]

When the stump of their child's umbilical cord fell off after four or five days, the new Yana parents sweated in a temporary sweathouse and were then washed with warm water by an elderly female attendant (*kunama'rimi*). The attendant also prepared fresh acorn soup. She cut a piece of dried meat in two, whereupon the man and wife simultaneously dipped the meat into the acorn soup and ate. At this moment they were free of the food restrictions (*mat'iyauna*) on salmon and deer meat they had endured since the pregnancy was first discovered. The umbilical cord was dried and then put in a miniature basket (*djukga*) that was secured to the cradle in the area behind the child's head, where it remained indefinitely.[27]

▶ *Cutting the Cord*

Among the Pomo, it was preferable for the umbilical cord to be cut by a member of the family. It was important that this person be wealthy and good-natured, as his/her disposition would influence the character of the child. The cord and the placenta were carefully buried in a secret location by a woman from the father's side. Some Pomo people deposited the material in a hollow tree, as to bury the

afterbirth might result in seepage into a flowing stream and defile others. To hide this material was extremely important, as possession of it by an evil person could result in the child's being "poisoned."[28]

While still attached to the infant, the umbilical cord was wrapped around a smooth, flat pebble and washed with an infusion of wormwood, *xa-am pi lulu.* Additional cleansing of the cord with this solution was considered essential.[29] The end of the cord was filled with powdered charcoal, and the cord and pebble were wrapped securely with a tanned buckskin bandage. This dressing was changed and renewed daily. The aromatic leaves of wormwood might be pounded or chewed into a pasty consistency to cover the end of the freshly cut cord.[30] And as a remedy for her pain, the new mother might lie upon a steaming bed of wormwood or be given a hip bath in water infused with the plant.[31]

A purplish splotch at the base of the spine, called *kawi xatapi,* was considered to be of great significance among some Pomo people. It was thought to have been caused by kicks from the next child waiting to be born, and thus a sign of continued fecundity for the mother. The extent of the spot and its depth of color were taken into consideration.[32]

The newborn Pomo infant was washed thoroughly in tepid water that included pine nuts and angelica root, using a loose bunch of tules or a wad of desiccated tree lichen as a sponge. The water was heated by hot stones. After this initial cleansing, a baby was usually washed morning and evening in a watertight basket by the father's mother. It was important that the basket be made by a woman

Left to Right:

▶ Umbilical Pebble, *xo'kabe*
Powdered Charcoal, *masit'bita*
Buckskin Bandage, *xoi pabem*
Obsidian Knife, *xaaka.*
AD 1000–1800. Obsidian. 3⅜ in. long. Marin Museum of the American Indian

▶ Mat, *bits'ao* (Eastern Pomo) replica 2001. Bev Ortiz, 1956–. Tule. 34½ in. x 75 in. Marin Museum of the American Indian. Replica patterned after a mat made by William Benson (Eastern Pomo). Woven mats of the round tule were in general use as floor mats, and placed on top of loose bundles of tule for bedding. Any number of mats were likely present in the structure during childbirth.

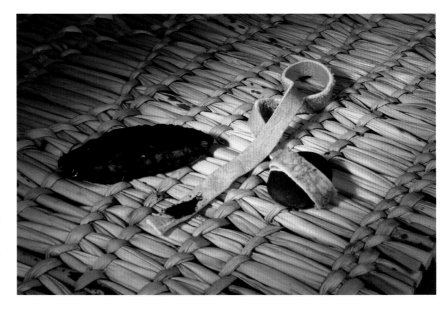

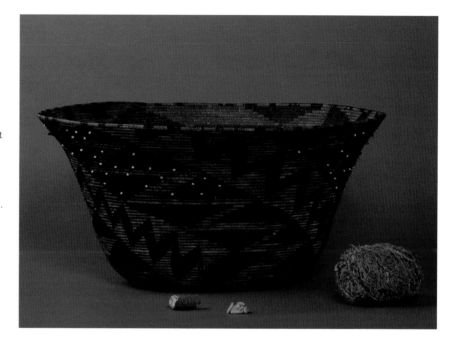

▶ Pomo Ceremonial Child Washing Basket, *tiribugu*, ca. 1890. Sedge root, bulrush root, willow shoots, glass beads, acorn woodpecker crest feathers. 8⅝ in. high, 16¾ in. diameter. Collected by C. P. Wilcomb, near Russian River (Mendocino County) ca. 1911. State Museum Resource Center, California State Parks. No. 5991W

 Sponge of tree lichen
 Bull pine nuts
 Angelica root

with good luck, who had no history of sickness. The washing basket was later carefully preserved by the child's paternal grandmother. If the child was a girl, she received the basket when grown; if a boy, he used it for pinole meal later in life. The basket was treated as an heirloom and rarely left the family.[33]

Infant mortality was high in pre-industrial societies the world over, so there was clear reason for serious caution before, during, and after birth. As Vivien Hailstone observed, "They never used to name their babies right in the beginning. There was a lot of them that didn't live." These traditions, and many more pertaining to the critical days following birth, appear to reflect the realities and concerns of negotiating both physical health and harmony with the spirit world. They illustrate how a couple, a family, and a community attempted to mediate these forces in an effort to exercise some degree of control over a tenuous situation.

It is impressive how far ahead people were looking, and how the actions taken before and immediately after birth were thought to have a significant impact on the child's long-term future. Occasionally this is visible on the cradle, but for the most part, the worldview of its maker and those who entrusted their infant child to it go unseen.

► Ties That Bind

The birth of a child meant that a new member had arrived in the family and the tribe, and the social interaction surrounding this event could illuminate and set into motion the entire social organization and structure of a community. It might determine whether the cradle should be made by a member of the father's or mother's family. Each birth formed new relationships within, and sometimes beyond, the local community. The formal exchange of gifts redefined and solidified relationships between families. Tribal social structure might also determine

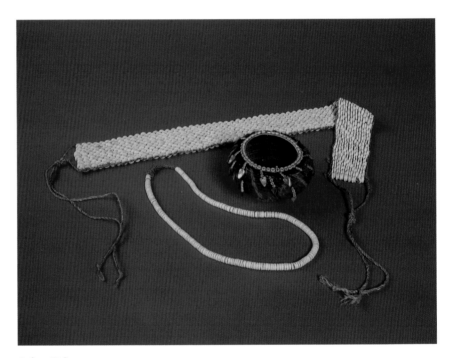

Left to Right:

► *Top:* Pomo Clamshell Bead Belt, *muki*, 2003. Belt woven by Lucy Parker (Kashaya Pomo/Coast Miwok/Mono Lake Paiute), 1953–. Beads made by Bill Snell. Washington clamshell, dogbane cordage. 25¼ in. long x 2⅜ in. wide. Marin Museum of the American Indian

► Pomo Clamshell Bead Necklace, *xebina* (when given for pregnancy), 1978. Salome Bartlett Alcantra (Yokayo Pomo), 1909–1991. Washington clamshell, cotton string. Overall length 23½ inches. Collection of Brian Bibby

► Pomo Gift Basket, *tasitol*, ca. 1911. Willow shoots, sedge root, acorn woodpecker crest feathers, meadowlark feathers, mallard duck scalp feathers, abalone shell, clamshell disc beads, jute cordage. 2 in. high, 4¾ in. diameter. State Museum Resource Center, California State Parks, no. 082–90–5957 (collected by C. P. Wilcomb near Kelseyville, Lake County)

an individual's name, as it was linked to paternal or maternal ancestors. The new mother's assistant during delivery, the individual who named the child, the weaver of the cradle basket: it mattered who these people were in terms of relationships, both familial and within the larger social framework of the community.

For example, within some Pomo communities, the birth of a couple's first child held greater significance than their marriage and ushered in much deeper associations. The birth created a new alliance, bound by blood, between two families. Their relationship was expressed by the formal exchange of gifts preceding and following the child's arrival.

As in most Native American societies, there existed an ethic of avoidance between mother-in-law and son-in-law. This was expressed by avoiding making eye contact or occupying the same space, and by a restriction against speaking to one another. The birth of a couple's first child was occasion for lifting the taboo. In some Pomo communities, there was a formal verbal exchange that marked this occasion. One example cites the mother-in-law initiating the exchange, stating to her son in law, *Ci-tci kawi, tsixa com* (Behold the connecting little one, the restriction is removed). The new father responds, *Kodi matcanodi, muca xaui kodi tala* (Generously you speak, my wife's mother. My heart with comfort is full).[34] This formal dialogue indicated yet another level of bonding between the two families.

A day or so after the child's birth, the maternal grandmother might present her daughter with a belt made from clamshell disc beads, an extravagance expressing significant monetary value. The belt was placed around the waist of the new mother. The mother's relatives also presented a gift of a lovely, small feathered basket filled with balls of pinole.

▶ *My Namesake,* oil painting by Grace Carpenter Hudson, 1895. Photograph courtesy of the Grace Hudson Museum and Sun House, City of Ukiah. Strings of clamshell disc beads adorn the wrists of the baby.

As soon as the father's mother or sister arrived, the new mother took off the belt and presented it along with the feather basket to her in-law, saying, "This is the child's gift to his grandmother." This reciprocated an earlier gift of a fine clamshell bead necklace presented by her in-laws when she became pregnant. If the father's family was satisfied with the mother's gift, they made a couple of long strings of clamshell bead money, often including valuable magnesite beads, and placed the strands around the wrists of the new child's mother the following day. Sometimes, small duplicates of these strands were placed on the baby's wrists as well.[35] These episodes of exchange mirror exactly the gift giving which occurs in Pomo mythology with the marriage of Spurred Hawk to Quail Woman.[36]

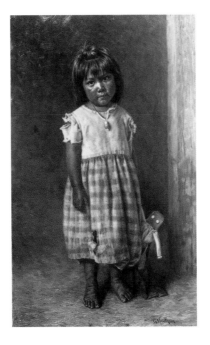

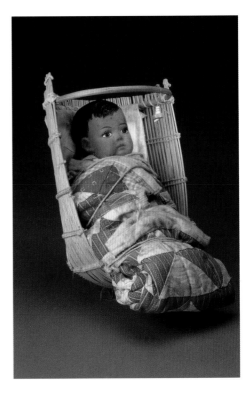

▶ *Home Care*, oil painting by Grace Carpenter Hudson, 1900, courtesy of the Grace Hudson Museum and Sun House, City of Ukiah. No. 172-A

A Pomo girl holds a doll that combines Native and non-Native materials and dress ideas: clamshell-disc-bead eyes attached to a small piece of wood, outfitted with a long-sleeved cotton blouse and long flowing skirt, with what appears to be an apron.

Right:

▶ Model Cradle (Pomo) and Doll, ca. 1910. Maker unknown. Willow, oak, cotton string, clamshell disc beads, magnesite, buckskin, cotton quilt. 11 in. long x 7¼ in. wide. Grace Hudson Museum, Ukiah

Deeply rooted networks of reciprocal relationships, often based on mythic models, orchestrated to facilitate binding alliances between communities, clans, families, and individuals illustrate a tremendous capacity to set the newborn child into a framework of completely articulated identity. And although some of these traditions have come to an end in some Native communities, there are still households in which the relationship of the cradle maker to the mother, father, and baby is very important. It is such a different cultural experience than how most Americans acquire a car seat or bassinet, through a retail merchant of no particular affiliation, plunking down the money and walking away with the necessary hardware.

▶ 'Ossatti: *Little Women*[37]

Throughout California, mothers and grandmothers made model-size cradle baskets for their children and grandchildren to play with. Young girls emulated their mothers, caring for imaginary children, learning the nuances of cradle use: how the infant should be placed in the basket, properly laced in, and how the basket should be carried, lain or set upright. Rather than a toy, it truly was a model

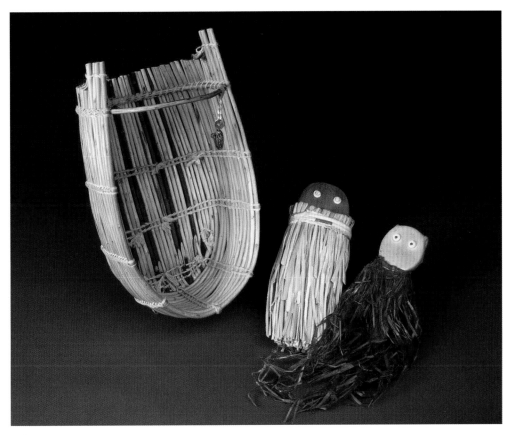

Left to right:

▶ Pomo Doll Cradle, ca. 1970. Maker unknown.

Willow, creek dogwood, cotton string. 12¼ in. long x 7½ in. wide. Marin Museum of the American Indian

▶ Pomo Doll (Lake County style), 2001. Replica

Cedar shake, clamshell disc beads, tule, cotton cord, rice-sack rag. 10 in. long x 3¾ in. wide. Marin Museum of the American Indian

▶ Pomo Doll (Coastal style), ca. 1980. Maker unknown.

Buckskin, clamshell disc beads, redwood bark. 15 in. long x 2¾ in. wide. Marin Museum of the American Indian

for future roles. Native cradle makers recall their childhood experiences with the little cradle:

I had a doll basket. My *hoochi*—that's my father's mother—made one for me. When we stayed at the mission [school in Northfork] we used to get dolls for Christmas. I would bring it home and put it in my doll basket and play like I had a baby.

—Ruby Pomona (Western Mono)[38]

Gramma made me a baby basket when I was about ten years old. I put my first teddy bear in it. —Ennis Peck (Maidu)[39]

My great-grandma would make dolls for us, and we'd make our own dolls. We'd take a piece of buckskin and make a head out of it . . . tie it. And then we had corn . . . we'd play with corn [cobs] and make little dolls. The hair would be real hair, and we'd put little clothes on it. —Vivien Hailstone (Karuk/Yurok)[40]

Everybody had one [model cradle]. We didn't have any [commercial] dolls to put in there. We had to have stick dolls or rag dolls. Pretty dolls, we never knew anything about them. Me and my sister made our own dolls out of rag. We'd make a round thing for a head, and roll it up for the arms and legs, and put some clothes on them. That was our doll. We had only one doll, my sister and I, in our lifetime.

—Laverna Jenkins (Atsuge)[41]

Some models, made from the trimmed remains of other weavers' baskets, might represent a girl's first attempt at weaving a cradle basket. There is also a history of model and miniature cradles being made for the tourist trade.

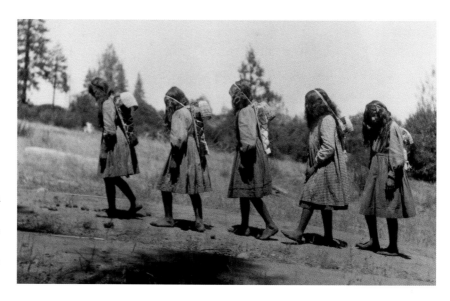

▶ Western Mono girls at Northfork mission school with model cradles, ca.1920 (photographer unknown), courtesy of the Phoebe Hearst Museum of Anthropology, University of California, Berkeley. No. 15–20938

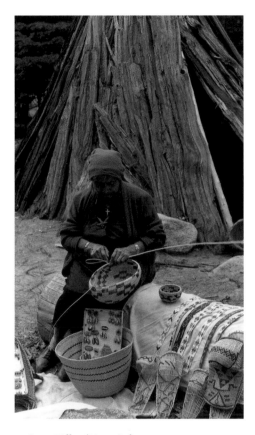

▶ Lucy Telles (Mono Lake Paiute) with model cradles for sale in Yosemite Valley. Photograph by Ansel Adams, ca. 1950, courtesy of National Park Service, Yosemite Museum. No. 4425

Right:

▶ Laverna Jenkins at Mount Lassen National Park. Photograph by Brian Bibby, 2001

The history of basket making in Laverna Jenkins's family is rich. Her grandmother, Nellie Gunsmith, was an accomplished weaver with a wide repertoire. She may have made the cradle Laverna was raised in. Laverna's mother, Dessie Snooks, also made baskets, including cradles. Older sister Lillian was instrumental in teaching Laverna the art. The continuity of the use of cradle baskets among her family, and in her community of Hat Creek, is impressive.

> I was raised in a cradle. I have pictures of my sister in one. My daughter was raised in a basket, and my grandchildren all had baskets. My great-grandson has a basket, he was raised in one too.

Traditional dolls were made from a variety of local materials, and they were often abstract in form. After Euro-Americans arrived in California, a variety of manufactured dolls became available and were readily incorporated into play with the indigenous basket. Western Mono weaver Francys Sherman has poignant memories regarding the gift of a fine porcelain-faced doll from her German grandmother:

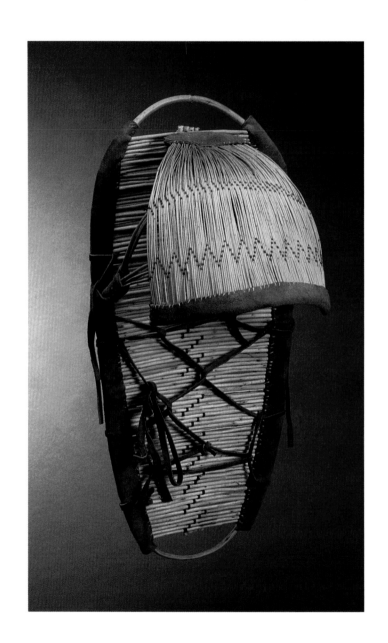

▶ Atsuge Cradle Basket
(model), *wahwasus*, 2000.
Laverna Jenkins (Atsuge),
1929–. Chokecherry, willow
shoots, yarn, commercial
leather. 21 in. long x 10 in.
wide x 8 in. deep. Marin Mu-
seum of the American Indian

I have my little doll basket yet that I had when I was little. I had a beautiful doll that was sent to me from Germany. We used to play with our little cradles when I was at the Northfork mission (boarding school).

At times, the doll cradle might express something beyond simple play—a playful hint, or an indication of things to come:

A newly pubescent girl, upon returning from her first stay in [the] menstrual hut may find that her friends, as a joke, have suspended a doll wrapped in its cradle over her bed area.[42]

▶ Yvette Goode (left) observes Sylvena Mayer (right) adding sourberry sticks to a baby basket at a workshop sponsored by the Fresno Arts Council, with funding from the National Endowment for the Arts Folk and Traditional Arts Program. Photograph by Amy Kitchener, 1995, courtesy of the photographer

A number of innovations have emerged over the years that reflect the incorporation of non-Native objects and ideas into Native cultures, and completely new ideas as well. The classic form of Euro-American baby rattles has been replicated by weavers in northwestern California for about a century. For the "noise makers" placed inside the rattle, Karuk/Yurok weaver Kathy Wallace likes to include a coin dating to the year the rattle was made, pebbles from the immediate area where it was finished, and a jingle bell. The handle of the rattle also serves as a teething ring.

The manufacture of miniatures by Native weavers in California also has a long history, as toys for their children, and for the collectors' market dating from the late nineteenth century. Christine Hamilton uses the familiar form of the Pomo cradle to create ear wear.

▶ On the Horizon

There has been a renaissance in the construction and use of baby baskets in Native communities throughout California over the past fifteen years. Local communities as well as statewide organizations such as the California Indian Basketweavers Association have sponsored workshops and arranged for the funding of master-apprentice programs. They have lobbied state and federal agencies regarding access to weaving materials in our forests, and worked with these agencies to develop policies regarding native plant management strategies.

However, despite such efforts and progress, older cradle makers continue to comment, "Nobody does this anymore." Is the glass half empty or half full? For those who were engaged in the Native American political and cultural activism of the late 1960s and early 1970s and have made a special effort to learn skills and

Left to right:

▶ Western Mono Cradle Basket (model), *huup*, 2001. Carly Tex (Western Mono/ Chukchansi), 1984–. Sourberry shoots, chaparral shoots, split winter redbud, sedge root, commercial leather, glass beads, abalone, yarn. 14½ in. long x 8¼ in. wide x 6¼ in. deep. Marin Museum of the American Indian

▶ Washoe Cradle Basket (model), *bic'oos*, 2002. Genevieve (McCann) Dick (Paiute/Shoshone), 1941–. Willow shoots, split willow, buckskin, yarn, glass beads. 15 in. long x 6½ in. wide x 5½ in. deep. Marin Museum of the American Indian

Carly Tex (Western Mono/ Chukchansi) made her first cradle basket model before she turned thirteen. One of Carly's teachers has been her grandmother, Avis (Tex) Punkin. The diamond pattern woven into the hood and back of the cradle is a standard gender marking for a female occupant.

Genevieve (McCann) Dick was born near Yerrington, Nevada. She did not take up weaving until the 1980s, learning to make cradle baskets from her mother, as well as Washoe weaver Goldie Bryant. Mrs. Dick's cradles are made in the Washoe style.

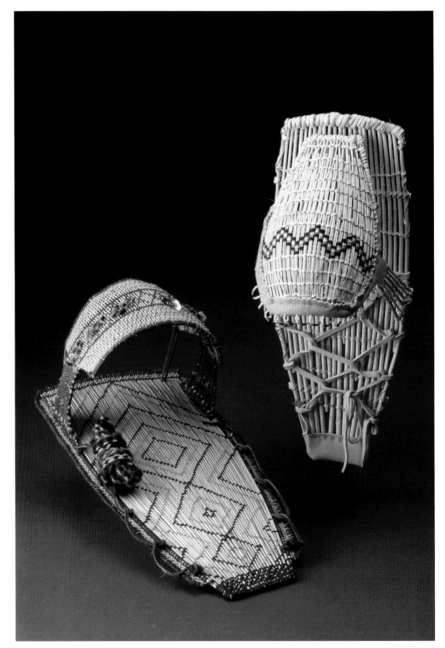

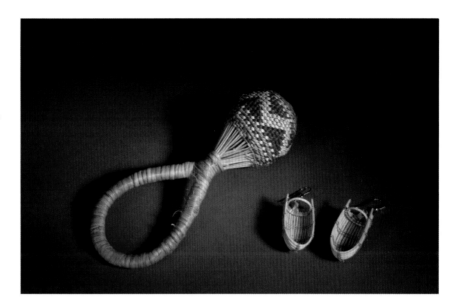

Left to right:

▶ Baby Rattle, 2002. Kathy Wallace (Karuk/Yurok), 1947–. Willow shoots, spruce root, woodwardia fern, bear grass. 5½ in. long x 2⅛ in. wide. Marin Museum of the American Indian

▶ Earrings, 2001. Christine Hamilton (Pomo), 1945–. Rattan. 1¼ in. long x ¾ in. wide. Marin Museum of the American Indian

traditions from elders they have sought out, it can be quite a blow to learn that one's own daughter doesn't want a baby basket for a child, for fear her friends will think it's weird or unhip, or because she doesn't necessarily want to separate herself by advertising her Indianness. The 1990s were not the 1970s.

As cradles have become less available over the past thirty years, their use has become more symbolic for some families. The chance to photograph one's child in a cradle, now often a family heirloom, establishes an important link with family history and tribal identity. Jenny Clark (Pomo), who lives with her young family within the urban setting of Roseville (California), explains that as a child she saw cradle baskets made by her great-grandmother, Myrtle McCoy (see page 37), adorning the walls of her parents' and grandparents' homes, and that she treasures photographs of her mother and herself in cradles during their infancies. Therefore, despite not possessing a cradle for day-to-day functional use, she definitely wanted a photograph of her son in one.[43] These subtle connections are especially important for individuals now living in urban settings, distant from tribal communities.

As with so many other issues and aspects of Native American traditions, it will continue to be a struggle. And there will be those who practice tradition no matter what, and those who will not. It is this fragmentation that makes the effort to maintain tradition so frustrating and enlightening, almost simultaneously. Yet despite a century and a half of political, economic, social, and religious upheaval, environmental degradation, and the ongoing processes of assimilation, the cradle

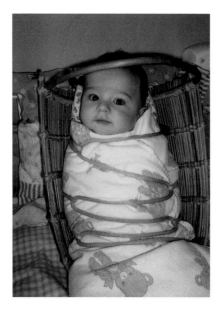

has been able to adapt and keep its significance in the midst of a rapidly changing, multicultural society. Remarkably, some children still find themselves looking out into their new world—the twenty-first century—secure in this product of an older world.

To those who do the work, and preserve the amazing nuggets of culture that give life such perspective and meaning, we are all indebted. You are saving a piece of the world for us.

▶ Alec Clark in cradle made by his great-great-grandmother, Myrtle McCoy. Photograph by Jacqueline Falleri, 2001, courtesy of Leona Sendldorfer

Notes

1. The population has been estimated at 310,000 plus or minus 30,000 (Cook 1955:315; 1978: 91)
2. Cook 1955:315
3. Emma Williams, Kawaiisu, as told to Maurice Zigmond (Zigmond 1980:185)
4. Rathbun 1973:52
5. Haine 1959:151–152
6. Anthony 1908:56
7. Chepo 2003
8. Bethel 1999
9. Ibid.
10. Hailstone 1999
11. Loeb 1926:246
12. Ibid.
13. Ibid., 247
14. Smith-Ferri 2000
15. Barrett 1952:387; Loeb 1926:246
16. Hudson, John, unpublished field notes. Grace Hudson Museum and Sun House, City of Ukiah
17. Loeb, 1926:256
18. Fenenga 1977:308–310; Goerke and Davidson 1975:9–21
19. Hudson, n.d.
20. Dixon 1907:457
21. Luomala 1978:602
22. Dixon 1905:325
23. Foster 1944:179

24. Sapir & Spier 1943:271

25. Sapir 1910:66

26. Ibid., 123

27. Sapir & Spier 1943:271

28. Barrett 1952:378. Loeb 1926:250

29. Hudson, unpublished ms.

30. Barrett 1952:377–378

31. Hudson, unpublished ms.

32. Ibid.

33. Loeb 1926:252, 256

34. Hudson n.d. ("Childbirth")

35. Loeb 1926:252

36. Hudson, unpublished notes

37. *Ossa-* (woman) *-tti* (diminutive), Northern Sierra Miwuk language. A general, playful term used to describe a girl (Callaghan 1987:285)

38. Pomona 2003

39. Peck 1999

40. Hailstone 1999

41. Jenkins 1999

42. John Hudson at Yokayo camp, November 5, 1901

43. Clark 2002

1 Sitting Cradles

▼ ▼

"Sitting cradles" are constructed so that the base of the basket forms a seat. Pomo cradles are formed of U-shaped rods tied together with cordage. A stout wooden hoop serves as a protective structure in the area of the child's head. In northwestern California, Tolowa, Yurok, Karuk, Hupa, and Wiyot cradles are nearly indistinguishable from one another. To the east, the Yana, Atsuge, Achomawi, and Wintu made sitting cradles similar to these, often including woven hoods.

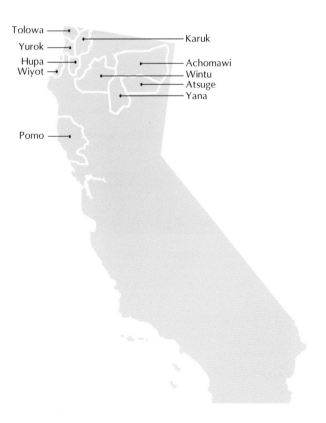

Tolowa · Yurok · Hupa · Wiyot · Karuk · Achomawi · Wintu · Atsuge · Yana · Pomo

▲ ▲ ▲ ▲

POMO

Cradle Basket, *sika*
ca. 1940
Maker unknown
Willow, oak, cotton cord,
tule swaddling
19 in. long x 12¾ in. wide
x 12½ in. deep
Marin Museum of the
American Indian

Deer Scrotum,
kawi a'ba'na mocha
Replica of original collected
by John W. Hudson at
Yokayo Rancheria ca. 1900
2½ in. high x 1½ in. wide
Marin Museum of the
American Indian

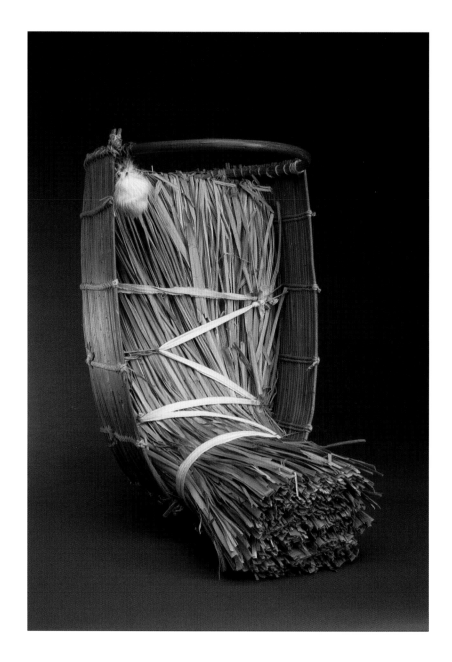

Although Pomo cradles may look alike to the casual observer, there are subtle differences. For instance, the back of this cradle differs from the next two examples in that the willow rods have been bent into successive U shapes, following the basic form of the basket. This style is often associated with Pomo communities in Lake County. The basket has been woven with commercial cotton string looped around the rods in twin half-hitches. Jute was also a popular cordage material for weaving cradles in the late nineteenth and early twentieth centuries, as it was readily available to people who worked in the many local hop fields. As Pomo cradle maker Christine Hamilton was told, "The ladies used to go and gather the string after the hops were harvested. They'd cut down the string so the hops would fall to the ground, and they'd get the string. I'm not sure what kind of string it was, but they used it a lot."[1] In pre-contact times, cordage made from native dogbane was likely used, and some Pomo groups may have used split sedge root.[2]

The cradle's function and practicality in a range of day-to-day living situations among the Pomo are fairly well documented. While a mother worked on her basketry, sitting with her legs outstretched, she might place the cradle across her lower legs and rock it by twisting her feet gently from side to side. When she was working in the field, the cradle could be set upright in a small hole that would keep the rounded base of the cradle from rolling over. At home, the cradle might lean against other, larger baskets in the household.[3]

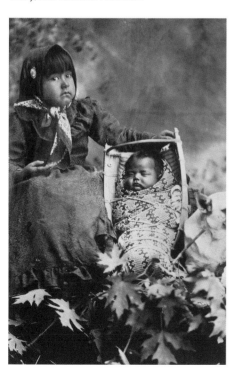

▶ Annie Williams Mitchell and infant (Yokayo Pomo). Photograph by Rena Shattuck, ca.1900, courtesy of Pierce Collection, Huntington Library, San Marino. No. 2652

If the occupant of the cradle was a boy, a stuffed deer scrotum might be suspended from the hoop. One of the few symbols that indicated the gender of occupants of Pomo cradles, it may have been associated with hopes for the child's future hunting prowess, or it may have been a symbol of male fertility. John W. Hudson also noted this feature on a Nisenan cradle he saw near Nashville in El Dorado County,[4] and another deer scrotum bag was collected by S. A. Barrett in 1906 from the Northern Miwok at Rich Gulch (Calaveras County), although records do not indicate context for its use.[5]

In the Clear Lake region, swaddling (*kalcuton*) was usually made of tule. The outer surface of green tule was peeled with the fingernail until there were enough strips to bind together at one end. A sharp-pointed basketry awl of deer bone was then used to finely shred the tule. Once dry, this bundle became a very soft wrapping for the infant. It could be used repeatedly, as it was easily washed. Once dried, it was as good as new.

The practice of swaddling infants remained a Pomo tradition

▶ Pomo woman carrying baby in cradle. Photograph by H. W. Henshaw, 1893, courtesy of C. Hart Merriam Pictorial Collection, Bancroft Library, University of California, Berkeley. No.1978.8.134.P1, no. 5

long after tule was replaced by cotton blankets. As Christine Hamilton explains, "They used to wrap their babies up tight, with their arms down . . . so they feel like somebody is holding them all night. Putting them in the basket and then tying them down makes them sleep longer. It gives them a sense of security, that somebody's holding them all the time. It's like a mother's arms."[6]

Shortly after a child began to walk freely, the cradle was deposited in a nearby body of water. Great care was taken to sink the cradle beyond the reach of anyone, as an evil person could afflict the next child by removing the sunken cradle and mutilating it.

1. Hamilton 2003
2. Bates 1999
3. Loeb 1926:256
4. Hudson n.d.
5. Phoebe Hearst Museum of Anthropology, University of California, Berkeley. No.1–10005
6. Hamilton 2003

▲ ▲ ▲ ▲

POMO

Cradle Basket, *sika*
1976
Myrtle Sanford McCoy
(Masut-keya Pomo),
1901–1992
Willow, oak, cotton string,
clamshell disc beads
18 in. long x 12½ in. wide
x 11 in. deep
Collection of Herb and
Peggy Puffer

Miniature Basket
1989
Julia Parker (Kashaya
Pomo/Coast Miwok),
1929–
Sedge roots, bracken
fern roots
⅝ in. high x ⅞ in. wide
Collection of Brian Bibby

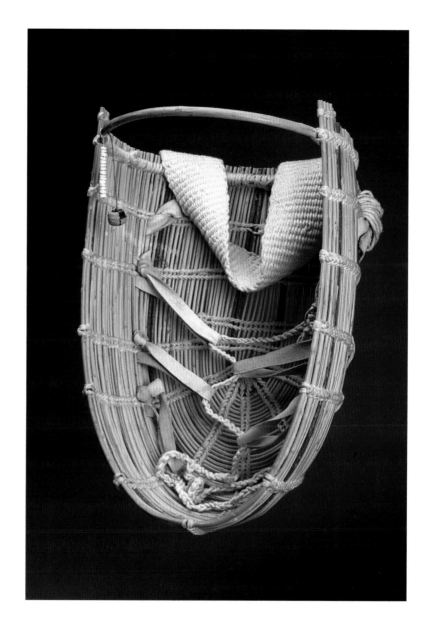

Born in Ukiah, Myrtle Sanford McCoy was the daughter of Belle Hildreth, a Musut-keya Pomo, and Oscar Sanford, an Englishman. The Masut-keya homeland was centered on the Russian River near the mouth of Seward Creek, close to Redwood Valley.[1]

All of Mrs. McCoy's children were raised in cradle baskets. Today, some of her descendants—as distant as the Los Angeles basin, and four generations re-moved—find themselves in a *sika* of her manufacture.

The cradle pictured on page 37 was commissioned by Pacific Western Traders (Folsom) in 1976. The woven tumpline was made by Myrtle's husband, Lawrence McCoy, who also made cradle baskets. (In some Pomo communities it was customary for men to make the cradle.[2])

Pomo cradles generally do not contain any gender markings or features, although among some Mendocino County Pomo, peeled and unpeeled shoots, usually dogwood or willow, woven to create alternating bands of white and red indicate the basket was made for a boy.[3] Another view of this banding was offered by Mrs. McCoy's daughter, Leona, who stated, "The color in the basket just gives it a little class."[4]

More commonly, gender was indicated, or read, through various auxiliary objects affixed to the *sika*. Miniature baskets were often suspended from the oak hoop of a girl's cradle, a prayerful wish that she might become a fine weaver.[5] Gender might also be indicated by the pattern of beads woven into the pack strap: straight or diagonal lines for a boy, diamonds for a girl. They are said to be abstract representations of the genitalia.[6] In addition, both girls' and boys' cradles were often embellished with strands of clamshell disc beads, *keya,* and sometimes a valuable bead made from magnesite, a mineral that was baked to create a warm, orange-red coloring.[7]

The practicality, safety, and stability of the *sika* made an impression on pioneer ethnologist John Hudson, a lifelong observer of Pomo culture. He also appears to have realized the deeper sociocultural role of the basket. At the turn of the century he wrote,

> On entering the tsi-ka, the "lot" acquires personality, gender, and the right to a name. An Indian baby loves his transport basket. It is his "baby buggy" in which he eats, sleeps, and travels. His toys are hung on the hoop, where he enjoys them only with his eyes, which may account for the most steady, penetrating gaze of any human being.[8]

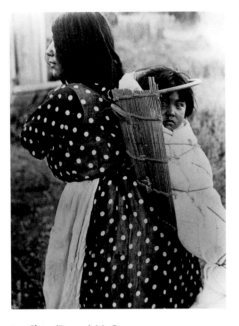

▶ Clara (Brown) McCaw (Pomo) and daughter Rose (Anderson) near Lakeport, ca.1919 (photographer unknown), courtesy of Lake County Historical Society

1. Kroeber 1925:30
2. Barrett 1908:166
3. Billy 2000.
4. Sendldorfer 2001
5. Loeb 1926:256
6. Hudson n.d.
7 *Keya:* Northern Pomo dialect of Mrs. McCoy, translated as "water bone"
8. Hudson n.d.

▲ ▲ ▲ ▲

POMO

Cradle Basket, *seka*
2001
Christine Hamilton
(Pomo), 1945–
Willow, cotton string,
commercial buckskin,
mourning dove
20½ in. long x 13¾ in.
wide x 10¼ in. deep
Marin Museum of the
American Indian

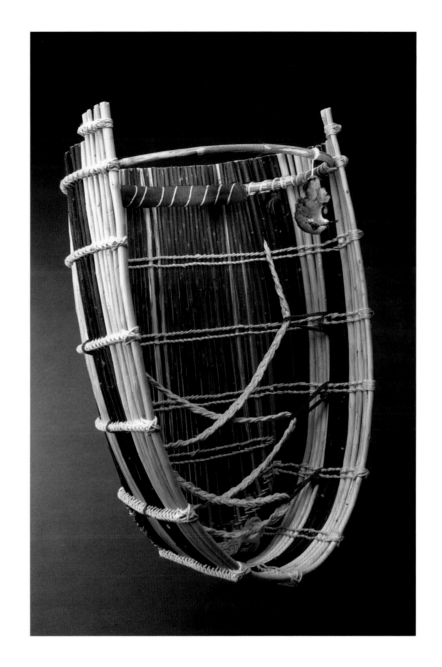

The preserved head of a dove suspended from the cradle's hoop was thought to make a boy mild-tempered, a desirable prerequisite for future community leadership roles. A quail's scalp might hang from the hoop of a girl's cradle. Such objects were known as *kawi-a-chan chilin*, "child plaything hanging."[1]

Christine Hamilton's cradle includes both peeled and unpeeled willow shoots.

▶ Clara Luff Mitchell, Christine Hamilton's paternal grandmother, and children at Yokayo. Photograph by S. A. Barrett, ca. 1906, courtesy of Herb Puffer

"Some I peel the bark off and some I don't, because I like the color of the bark in the baskets." The peeled shoots are gathered primarily in the spring, when the bark slips off easily, leaving shiny, white wood beneath. Shoots gathered in the late fall have a dark, reddish brown bark that has bonded with the wood.

Christine pre-forms shoots into the characteristic ∪ form of Pomo cradles, tying them with rags and then setting them aside to dry. "It takes maybe two or three months to dry really good. It keeps the shape when you take the rag off, and then you start making your basket."

The circumstances that led Christine Hamilton to become a basket maker illustrate a cultural, social, and economic environment quite different from that of her ancestors in the nineteenth century. In generations past, Pomo women wove as a necessity for living, whether for food collecting, fulfilling social and ceremonial responsibilities and expectations, or even for selling in the collectors' market of the late nineteenth and early twentieth centuries.

Christine's is a deeply personal journey, one influenced by despair but also by a realization of her connection to her family and tribal history. The making of cradle baskets has become an identity marker for Christine, and now it is in turn stimulating a renaissance of cradle use in her region.

Christine was born and raised at Yokayo, a privately owned, independent Pomo community three miles south of Ukiah. At age nineteen, she attended basket-making classes taught by the late Pomo master weaver Elsie Allen. "I was looking for something, I guess. And then I just decided to learn how to make baskets out of nowhere. Probably because I was Indian. This is something I should

know how to do," recalls Christine. "It's just something that I felt I had to learn—part of my inheritance . . . it's something that's inside of me and it's comin' out in the baskets."

It wasn't until some twenty-five years later that Christine began to make baskets in earnest. "I used to do a little bit just to keep remembering how to make them. But I used to gather a lot. So I was gathering all the time—all those years—but I wasn't really working on baskets, because I was young and crazy and I was experimenting with alcohol, and I didn't feel like it was the proper thing to do—to use alcohol and then to make the basket. So I didn't mix them."

After the tragic death of her son in 1990, Christine found herself turning to basketry. "I stopped drinking, and that's when I needed something that would keep my mind without hate that I had for this boy that killed him. So I started doing baskets and that gave me strength. When I did the baskets, it was like a calming inside. And you know, you just sit there and you work on the basket and it makes you feel better. And so that's how I survived that."[2]

1. Hudson n.d.
2. Hamilton 2003

▲ ▲ ▲ ▲

HUPA

Utility Tray, *q'aytel*
2001
Marilyn Hostler (Hupa),
1938–
Hazel shoots
24⅜ in. diameter,
3¾ in. deep
Marin Museum of the
American Indian

Cooking Basket, *mi*l*toy*
ca. 1910
Maker unknown
(Hupa/Yurok/Karuk)
Willow shoots, conifer
roots, bear grass
13½ in. diameter,
8½ in. high
The Haggin Museum,
no.1943.44.18

Cooking Stone
Douglas Fir Bough

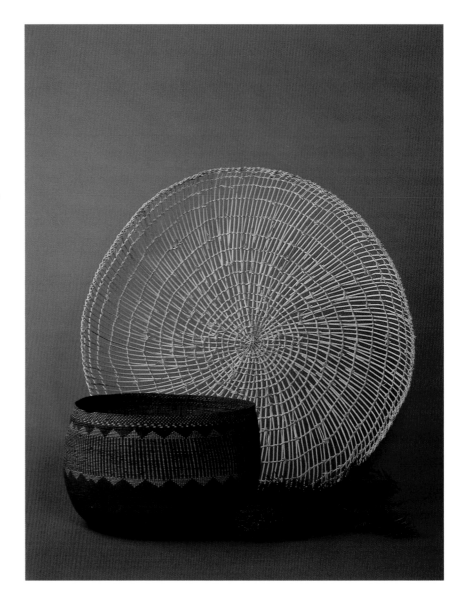

Newborn Hupa infants were initially wrapped in a blanket and placed in the *q'aytel,* a basket ordinarily used for a variety of household tasks, including the cleaning of acorns.[1] The first ten days of life were considered a critical period in the baby's survival. In an effort to counteract any negative forces that might cause the vulnerable infant sickness or death, and to procure a good future for the child, a doctor was often summoned to make medicine. Medicines could make the child grow fast, make it grow strong, or cause the child to reach old age. A doctor who knew the medicine sought the herb in the mountains and repeated before it a long formula which detailed the discovery of the plant and its remarkable benefit to the first child it was used for. An excerpt from the ritual formula to cause an infant to grow strong recounts the discovery of Douglas spruce (i.e. Douglas fir), used in steaming infants:

> "With what am I going to steam it?" She went down to the river and picked up some blue stones [used, when heated, to boil food in a cooking basket] which she carried to the house and put in a basket of water. Then she went out again to get the herb for the medicine she was going to make. She saw small Douglas spruces growing, about two feet high. These she broke off, leaving only one standing. She sat down facing the south. "This way it will be," she said. "One always will be left, toward which we shall talk."
>
> Then she put the spruce branches in the basket of water, under the baby. Several days later the basket-plate . . . spread out and broke. After five days it did that again. After five days more she put it in a baby basket. The baby basket broke. She put it in a second one and leaned it up against something. The baby kicked up its legs.[2]

The spruce boughs were placed in a cooking basket, *miłtoy,* which was filled with water heated by the blue stones, which had been made red hot in a fire. The infant, secured in the *q'aytel,* was held over the steaming basket. After ten days, a lock of the infant's hair was cut off and put in the fire. It was thought that the divinities, upon smelling the burning hair, became cognizant of the child's existence for the first time.[3]

1. Goddard 1903:52
2. Goddard 1904:291
3. Goddard 1903:51

▲ ▲ ▲ ▲

TOLOWA

Cradle Basket, *gayyu*
2001
Loren Bommelyn (Tolowa),
1956–
(Basket money by Lena
Bommelyn; pillows, straps,
and tumpline by Vicki
Rodriguez)
Hazel shoots, split spruce
roots, dentalium shells,
glass beads, cotton
20½ in. long x 12 in. wide
x 7½ in. deep
Marin Museum of the
American Indian

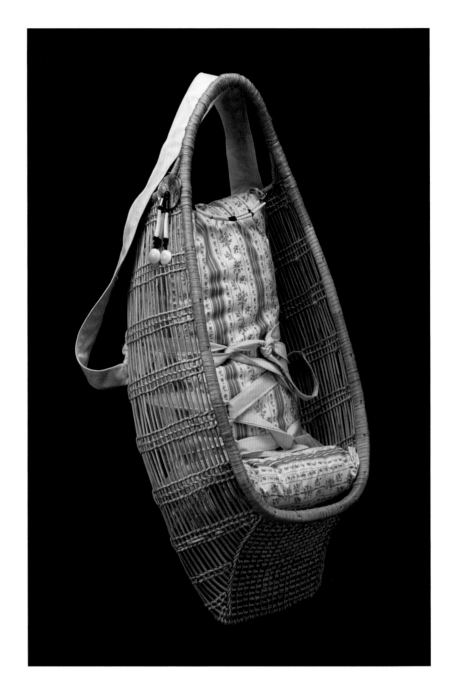

Loren Bommelyn was raised in a cradle basket, and the practice has been a strong tradition in his family; for the Bommelyns, the *gayyu* is a normal element of an infant's experience. "It's a house for your baby. It's their refuge. In my family, it's used for more than just traveling; the baby sleeps in the basket at home during the day. And when they're sick or cranky, they seek out their basket . . . they want to be there."[1]

This sense of security, so evident in Loren's observations, is further demonstrated in the traditional practice of swaddling: wrapping or bundling the baby securely, with its arms often bound within. "We believe in swaddling. I don't understand why non-Indians don't do that. They think it's cruel. It's not. I often see non-Indian babies thrashing around in cribs, unrestrained."

It seems that western medicine is coming around to the idea of swaddling. Harvey Karp, M.D., writes, "Babies don't need freedom. They need protection and security. Inside the uterus, they can't move their arms, so it makes sense to wrap them."[2]

Interest in raising one's baby in a *gayyu* and the desire to do so have remained strong over the past several decades, and Loren has been among the busiest weavers in the state, making over one hundred cradles to date. "I don't care how assimilated a family might be," he states. "When a baby is born, they want a [baby] basket."

Traditionally, a newborn Tolowa was laid in a utilitarian basket tray for the first ten days of life. The basket was folded, somewhat "like a taco shell" as Loren explains, for added security. After ten days the baby entered its first of three cradle baskets, each increasing in size to accommodate the growing child. The third and largest *gayyu* usually holds a child until it is two and a half years old.

Among the Tolowa (Yurok and Karuk as well), subtle variations in the cradle basket's shape reflect the gender of its occupant. A boy's cradle generally has a square or straight-sided appearance, while a girl's cradle is wider at the base. Regarding the latter, Loren explains, "In those days, if your hips couldn't pass a child through, then you died in childbirth. So it was a concern that you didn't want to start a girl out in life in a narrow basket. You didn't want her to have that limitation for any reason."[3] A boy's basket may have a small slat of redwood woven into the back, about where the child's shoulder blades rest, and a miniature bow might hang from the cradle's side. A dangle of shells might be suspended from a girl's basket.

The strands of dentalia adorning the upper portion of the cradle are a payment to Frog and Lizard, Loren explains:

[The baby will] be sound asleep, and all of a sudden they'll gasp . . . start . . . and just cry, out of the blue, and you're thinking, What the heck happened? What it is, Lizard comes and tells them stories, frightening them, and Frog Man puts their feet in the water. Lizard always bothers the boys, and Frog bothers the girls. So you pay 'em off by putting this [dentalium shell money] up here. Then they leave your baby alone, so they won't cry.

All the women, they'd always hum while holding the baby or bathing the baby. There was one song about this little boy . . . when you give them a bath, well, they'd dance him and his little penis bounces, and they sing about that. You know, just little songs. But then there are lullabies to put them to sleep. One says, *gay-yuu-du' dan' tee-lalh,* "that baby is already sleeping."

The main structural rim of the basket, the oval of hazel sticks wrapped in the darker-colored split spruce roots, has major symbolic importance and is referred to as the "life line." Upon the unfortunate occurrence of an infant's death, the cradle's life line was broken, and the basket, with baby inside, was taken to the woods and left. Loren says that after seeking out one of the enormous maple or myrtle trees that were common before the local forests were heavily logged, "They would crawl up in that tree, way up there, and find a nice, deep crotch in a limb, and set that baby [in its cradle] in there, and leave it there. That was what my aunt saw them do."

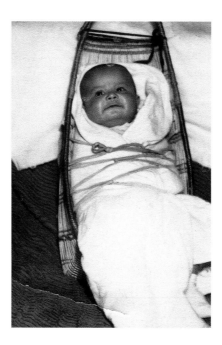

▶ Loren Bommelyn, 1956. Photograph courtesy of Loren Bommelyn

Right:
▶ Loren Bommelyn, Crescent City. Photograph by Brian Bibby, 2001

Because of its association with death, any chance breakage of the life line is strenuously avoided. "In the house I grew up in," Loren explains, "you never held the basket by . . . well, some people call this a handle, but this is not a handle." One does not want to risk fracturing the baby's life line by lifting or carrying the cradle by this rim. "That's why this strap is here, this *t'uule* (tumpline)," Loren adds, "because you hold the baby this way, you grab this strap."

Loren is aware of only one instance when it was acceptable to hold a cradle by the life line: "If your canoe capsizes, then you grab that life line and hold your baby's face above the water, and drag 'em to shore . . . get yourself to shore. That's okay then, because it's a catastrophic situation. You've got to get them home, get them to the shore."

In former times the tumpline was an essential part of the basket, passing over the mother's shoulders or the top of her head and allowing her to carry her baby and have her hands free. The Tolowa wove tumplines of native fiber, and Loren's family still possesses one of these. He says tumplines are still used in his family, regardless of changes in lifestyle. "In modern times, less and less people are putting these on their baskets. But this is a tool, this is the handle of the basket right here. We still include the tumpline on the basket. We might tie it to a chair or something, allowing the baby to be upright."

Perhaps the most important detail of a baby basket is the material it's made from. For the Tolowa, the strong, tough shoots of hazel were chosen for both warp and weft. Loren learned the essentials of gathering basketry materials from his mother, and he has over the past three decades become intimately familiar with the many nuances of cultivating, selecting, locating, seasoning, and manipulating the shoots of the hazel bush. The casual observer is generally quite stunned by this acute, holistic knowledge about a plant species and the environmental factors that contribute to desirable characteristics for specific functions.

Loren's basketry, regardless of type or style, is noted far and wide for quality of materials as well as skilled construction. It all starts with knowing exactly what you are looking for—having an eye for quality. Besides an amazing degree of observation, the special quality of Loren's baskets also results from a meticulous attitude at the initial stage of their creation.

We get [hazel sticks] in the spring, when the bark is peeling. There's only about a two-week window, that's it. If you get them too early they're not peeling, and you have to scrape your sticks. And I don't like scraped sticks, because you scrape off the shiny part, and I don't like that, personally. They'll fill with sap on the tip first, before the base. If you go too early, they'll peel at the very tip, and then you have to scrape the base. Then if you wait too long, or you get behind, then the side shoots get too long and they start getting those big nubs on them, and then they're no good again. Plus, the stick actually

starts going from being straight to becoming crooked, because it's getting ready to put a limb on. It starts walking. You get them in the perfect time, then the whole thing just comes off.

You want to make sure you pick long, slender sticks. You avoid short, fat sticks, and sticks that are laying on the ground [i.e. growing sideways from the base of the shrub], because they've got too big of a heart, or pith, and they're weak. And if the deer ate the tip off when it was growing the year before, it will cause a little weird fork, or it'll be stubby . . . avoid those. If the deer get in there, they'll wreck most of them, because they feed on that, they like to eat that. Look for sticks that have a tip on the end. When you're picking sticks, you're looking for the longest, skinniest ones you can find.

The most desirable sticks often appear after the shrubs have been burned. Loren notes a difference in sticks from hazel shrubs that have been pruned and those that have been burned: "Burning is best, because those cut-off ones are actually re-growing from a stump, whereas the burned ones have been killed clear down to the ground level, and then it somehow comes straight up out of the dirt, so the sticks are straighter. Also, the pruned ones are usually shorter too, they're not as long."

After the sticks are gathered, Loren sorts them by size, and then they are dried or cured. A hallmark of Loren's work is the evenness of his material, accomplished by diligent sorting:

I grade my sticks, always. *Num-nii-la* means to go through them and make them even. *Taa-tr'esh-lvsh.* . . . I'm grading them. [For] my aunts and everybody I went to when I was young, that was a key point: always grade your material. There's about five sizes, generally. So you pick out all your sticks that are going up (warps), and then you pick your weavers (weft sticks) out, and you look for the ratio of the weaver to the stick. I like to let them dry for months before I use them. I dry them in the sun, every day, bleach them in the sun, and roll them around. I pick them up at night and then put them back out in the daytime.

To counteract warping during the drying process, Loren adds, "You twist 'em. You grab handfuls and you go like this . . . *yaa-k'vn* (alternating twisting motion between the two hands), and if there's any kind of weird things you straighten 'em, that first day. After that you'll just bust 'em off, because they're drying already. But that first day, after you peel them you can work them a little bit."

After the hazel sticks have been peeled, sorted, bleached in the sun, and fully dried, they are candidates for weaving. Upon making a new *gayyu,* Loren will soak the selected sticks for about twelve hours in order to make them pliable. Once this is done, he will generally try to finish the basket within a day or two:

I don't like to re-soak sticks unnecessarily, because it kind of wrecks them. If you leave them soaked for longer than a couple of days, the sticks begin to break when you weave, they start busting up. They're oversaturated or something.

I have to work all day [teaching school], so I weave the seat and the first and second rows of three, and then it'll be midnight. The next time I'll weave the whole thing. I can leave it sit then for a week, wrapped, and that's fine. Also, your hands get sore, and you don't know they're sore until the next day. So it's better to get it all done with, because the next day your fingers hurt. If you make baskets all the time your hands get tough anyway, but there's that time when it can get really sore from pushing all that material around [with] your fingertips.

Loren Bommelyn's dedication to his basketry, his culture, and his language has been profoundly influenced by his exposure to Tolowa tradition. Lessons learned from elders instilled within him the real world of Tolowa values.

When we were taught to make baskets, and talked to old people, they would say, "Whatever you make, never say to yourself, 'Ahh . . . that's good enough.' Always do the best you can. And when you make something, make it to last. In your mind, when you're making something, it's for a purpose, so make it strong as you can. Never make anything flimsy or weak." That was just their basic instruction. And what's kind of interesting is, those teachings become your judges. You're thinking of all those eyes watching you. How would they see that? Those judges become a very important part of your life, because they watch you all the time.

1. This and subsequent unmarked quotations on the Tolowa: Bommelyn 2001
2. Karp 2002
3. Bommelyn 2003

▲ ▲ ▲ ▲

YUROK

Cradle Basket, *nah'ahs*
2000
Pat Hunsucker (Yurok),
1933–
Hazel shoots, split
sugar pine roots,
dentalium shell, glass
beads
27 in. long x 12 in. wide
x 6½ in. deep, face guard
diameter 7½ in.
Marin Museum of the
American Indian

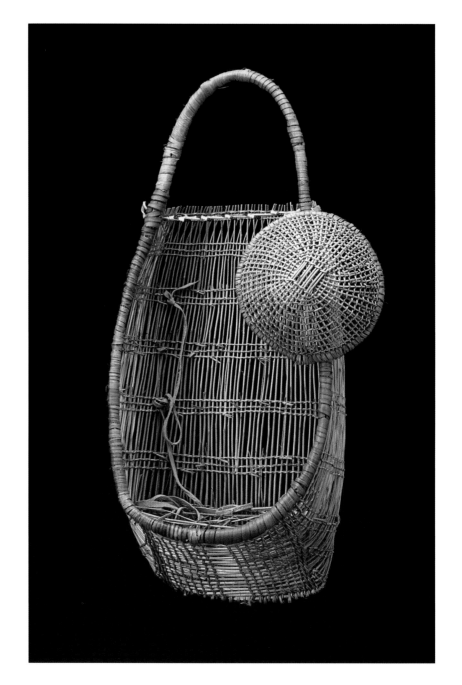

P at Hunsucker was born at Blue Creek, near the ancestral Yurok village of Ahpah, on the lower Klamath River. She is very actively involved in making baby baskets. Yurok people living along the Klamath River, and in the cities, continue to use the *nah'ahs,* and the baskets are in great demand today, much as they were throughout the twentieth century.

Except for the rim binding of split pine roots, this cradle is made exclusively from the sturdy shoots of hazel. It's well known among Yurok weavers that it takes strong hands to successfully manipulate the tough, large hazel shoots required for a *nah'ahs.* Thus, there have always been certain women who specialized in making baby baskets.

The availability of high-quality hazel has been problematic over the past several decades, as hazel requires frequent burning to produce clear, straight, supple shoots. Half a century of fire suppression policy has created dense growth and undesirable material. However, recent efforts by local weavers working with forestry officials have resulted in controlled burns of hazel habitat. Fire has always been a great friend of basket makers throughout California and the West.

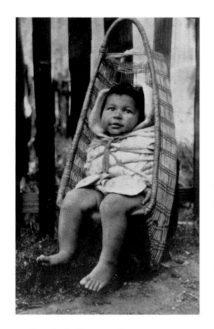

▶ Yurok child in cradle, ca. 1900 (photographer unknown), courtesy of Charles Festerson

Strands of dentalium shells strung across the top of the cradle represent the "life line." The small, circular plate attached to the cradle can be used to protect the child's face from branches when traveling along a trail, from direct sunlight, and to shield against insects such as bees, wasps, or grasshoppers. When not in use, it's tied to the side of the *nah'ahs.*[1]

A baby may have occupied three or four successively larger cradles by the time it reaches two years of age. Mothers often brought a measuring string to the weaver to gauge the length for the new cradle.[2]

Vivien (Risling) Hailstone, the late Yurok/Karuk weaver, reminisced about her childhood home at the Yurok village of Morek and the use of baby baskets in her family:

When a baby is first born they're wrapped, tied in the basket, and they're comfortable, because they just came from a pretty tight place, and they just somehow are more comfortable that way. They sleep better. The little tiny babies, they strap the hands in. As they grow a little older they have more freedom with their hands and feet. Sometimes, a little kid (a year or two old) would get up, still strapped in its cradle, and walk along with his basket on his back. They looked like little turtles.[3]

1. Hailstone 1999
2. O'Neale 1932:34
3. Hailstone 1999

▲ ▲ ▲ ▲

KARUK

Cradle Basket, *thaxtuuy*
2001
Wilverna Reece (Karuk),
1946–
Hazel shoots, split spruce
roots, bull pine nuts,
abalone shell, glass beads
27½ in. long x 12½ in.
wide x 7 in. deep
Marin Museum of the
American Indian

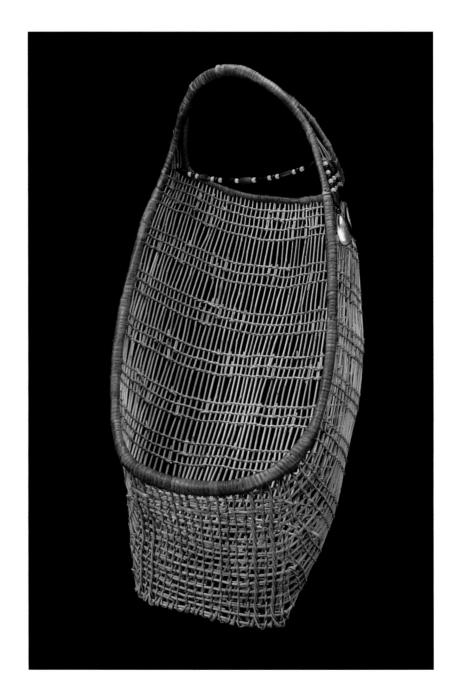

Wilverna Reece has spent most of her life in the upper Klamath River region of her ancestors. She began learning traditional weaving from Karuk elders Grace and Madeline Davis in 1978. Although she enjoys making other types of Karuk baskets, regular orders for the *thaxtuuy* occupy much of her weaving time.

Karuk cradle baskets share much the same form as others in northwestern California (Hupa, Yurok, Tolowa, Wiyot). The origin of this basket among the Karuk is articulated in a myth. *Pishivava* (Large Dentalium Shell) is credited with creating several important elements of Karuk life and culture, including human beings, towns, clothing, sweathouses, acorns, dances, gambling, laws, babies, and cradles.[1]

> Then he thought, "I will show the people. I will make a baby and a cradle for it." So he made a cradle, and everything with it, complete. He thought, "You people will do this way. You are the ones who will do this when you have a baby." He put the baby into the basket and made everything for it. He cut off its navel string and hung it on the side of the cradle. With it he hung up a dentalium [shell], a piece of the smallest size. He thought, "You will do like this when you have babies. If it is four years and the baby remains [alive], take this navel string up on the hill. Find a little fir [tree] on the hill, split it, and put the navel string into it. Leave it there and come back. Do this and the baby will be well. If you do not do it, the baby will not be very strong. It will be soft, and it may die quickly. But if you do what I am doing, the baby will be well and strong." Now people always do that.[2]

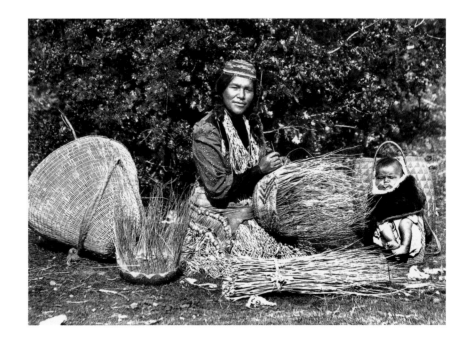

▶ Phoebe Maddux (Karuk) and child in cradle, 1897 (photographer unknown), courtesy of the National Anthropological Archives, Smithsonian Institution. No.75–16219

The myth goes on to ordain how newborns should be fed during the first five days of life. Rather than nurse newborn infants on mother's milk, *Pishivava* instructs the people to mash pine nuts into a fine meal and add water so it is "just like milk."[3] There is a sense that a newborn may lack the strength in its mouth to nurse satisfactorily. *Pishivava* says, "It will not do like that [suckle], the baby, it can do nothing."[4]

The fragility of life, particularly in respect to infants and young children, is apparent in the Karuk tradition of not naming children until they were several years of age. One reason given for this practice was stated as, "If they died young, they would not be thought of by their names."[5]

1. Kroeber & Gifford 1980:74-75. Sweet William of Ishipishi told this myth to Kroeber in 1902.
2. Ibid., 79
3. Ibid., 80
4. Ibid.
5. Kroeber 1925:107

Cradle Basket, λ'ol
2001
Michelle Noonan (Wintu),
1965–
Willow shoots, split sugar-
pine roots, commercial
buckskin
27½ in. long x 13¾ in.
wide x 5⅝ in. deep
Marin Museum of the
American Indian

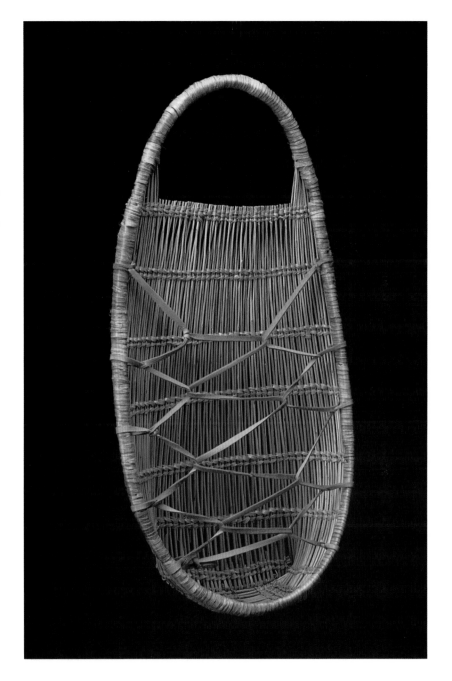

The manufacture of Wintu cradle baskets had been mostly dormant for sixty years when, in 1987, Michelle Noonan took her first step toward resurrecting the tradition. The late Yurok/Karuk weaver and teacher Vivien Hailstone instructed her on basic techniques of twining, and on the process of gathering the

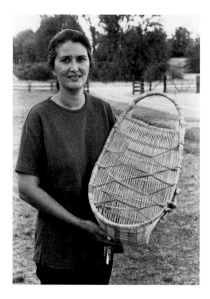

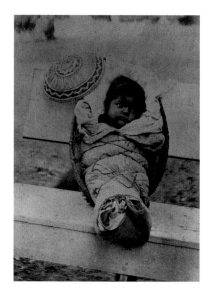

▶ Michelle Noonan, Redding. Photograph by Brian Bibby, 2001

Right:

▶ Child in cradle near Bartlett Mountain, Long Valley (Patwin?), ca. 1900 (photographer unknown), courtesy of Robert J. Lee, Dodge Family Collection. No. 00794

The Patwin, southerly linguistic cousins of the Wintu, apparently made the same type of cradle as the Wintu. Little is known of Patwin cradles; this image offers a rare glimpse at cradle use in that region. The woven disc is apparently a face shield to protect the infant from insects and branches, and to afford partial shading from the sun, as was customary among the Hupa, Yurok, and Karuk. The disc includes two close-twined bands of design, while the remainder is open work, allowing air flow so that the child can breathe freely.

materials that were traditional to local weaving. Michelle also sought out Wintu cradles in museums and private collections to study their characteristic form and weave. Since then, demand for her work has been growing among young Wintu parents anxious to raise their children in these traditional baskets.

The Wintu cradle is of the "sitting" type, meaning the child sits on the broad interior base of the basket while its legs extend over the edge, often wrapped within the swaddling. The cradle baskets of the Atsugewi and Yana people to the east are very similar in style, with a woven trapezoidal hood added. Among the Wintu, a small, twined disc was often used with the cradle as a covering to protect the child's face from insects or brush.

Traditionally, Wintu women and their husbands observed a number of restrictions as the time of birth grew near. A woman would not wear a necklace for fear it would cause the child to be born with the umbilical cord wrapped around its neck. As she lay down at night, she might slide a stone pestle down the length of her body, prefiguring an easy delivery. Women withdrew to the menstrual house for the final month or so before birth and abstained from meat, salt, and cold water.[1]

A small receiving basket, *tcuri* λ*'ol*, was used to hold the newborn child. When the new mother left the seclusion of the menstrual house and returned to her family dwelling, the second cradle, λ*'ol*, was made ready. Some families observed a minor ceremony at this point. The father gave the new cradle to a man known to

be a fast runner, who then sprinted a short distance with the basket, or else circled the dwelling. If the child was a girl, a woman ran with the basket.

After a child's umbilical cord dropped off, it was put in a finely twined miniature basket and attached to the cradle, where it generally stayed until the child began crawling and the λ'ol was no longer needed. The destination of a child's umbilical cord might influence his or her future character. If alertness was the desired trait for a boy, his cord was tied to the limb of a live oak. A mild and pleasant demeanor might be achieved by tying a boy's cord to a skunkbush, a girl's to a manzanita.[2] Some local traditions called for the umbilical cord to be buried. If a child was observed with his ear close to the ground, it was believed that he was listening to discover where his cord had gone.[3]

When the cradle was outgrown, it was often hung in a tree and left to disintegrate.[4] If the cradle lasted a long time in the tree, it was a sign of long life for the child.[5]

1. DuBois 1935:45
2. Ibid., 46
3. Ibid., 46, 47
4. Ibid., 46
5. Noonan 2001

▲ ▲ ▲ ▲

ATSUGE

Cradle Basket, *yup-ahdi*
ca. 1950
Maker unknown
Willow shoots, split willow
shoots, commercial yarn,
steel wire
18 in. long x 13 in. wide
Collection of Herb and
Peggy Puffer

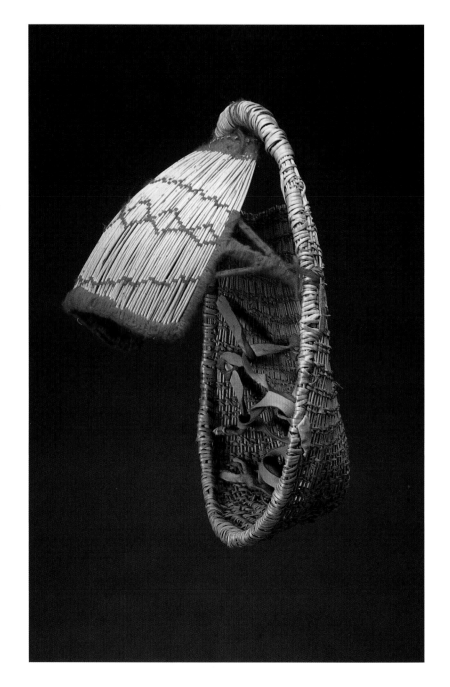

Then the grandmother said, "I'll tell you what to do. I'll give you a baby basket," and she brought one. "Put the baby in this and tie him in. Do not use buckskin; use *Us'le*, the spider's rope, so that neither wind nor anything will break it."[1]

—from the myth of Annikadel

One of the two styles of cradle made by the Atsuge was a sitting style reminiscent of neighboring Yana and Wintu forms. The framework for the hood of the cradle pictured here includes wire, adapted for use because of its obvious strength and flexibility. Atsuge elder and weaver Laverna Jenkins says this was the infant's first cradle basket, although among some Atsuge, receiving cradles were made of tule. A larger, straight-backed form was used after the baby had grown a little.

The Atsuge, like other Native Californians, saved their infants' umbilical cords once they fell off. A tradition among some Atsuge was to tie the cord with strands of the maternal grandmother's hair. It was then put in a small buckskin bag and attached to the basket.

When a child outgrew its cradle, the basket was tied to a tree. Laverna Jenkins explains, "As the tree grows, the baby grows also." A new, larger basket was then made. In former times, a cradle would not be reused for other babies.

Samson Grant, an Atsuge shaman of the early twentieth century, once spoke of the moon's importance within Atsuge cosmology, and of the personal ritual a new mother might observe to ensure good health for her child:

Every month when the moon was new, little boys and little girls would run. They would lift up their arms and say, "Look Grandma, how big I am, running for you." The mothers took their little babies out of their baskets and held them up to the [new] moon. The mothers would speak for the babies; they would say, "Look Grandma, aren't I big? Aren't you glad I have grown so big?"[2]

1. Woiche 1928:49
2. Park 1986:12

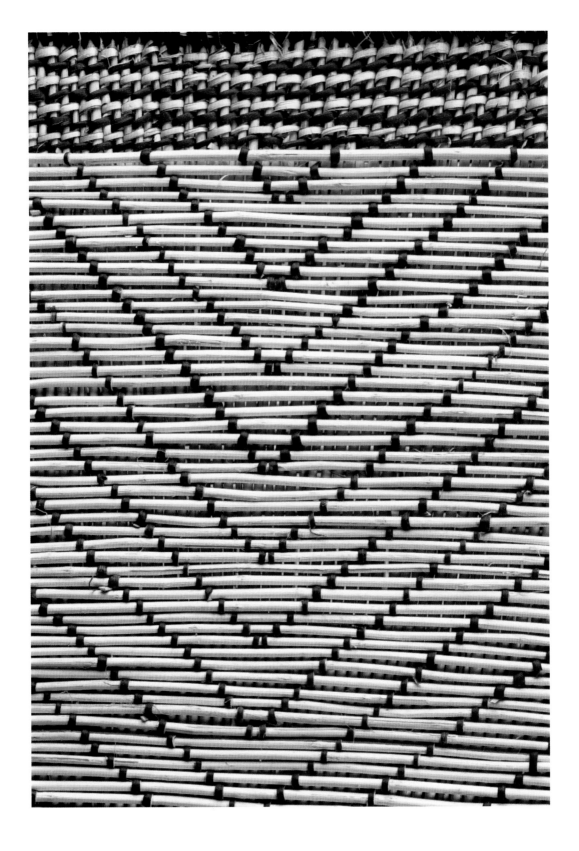

2 Rectangular Lie-in Cradles with Hoods

▼ ▼ ▼ ▼ ▼ ▼ ▼ ▼ ▼ ▼ ▼ ▼ ▼ ▼ ▼ ▼ ▼ ▼ ▼

This style of cradle, upon which the baby lies on its back, is common throughout the eastern slope of the Sierra Nevada and into the Great Basin among the Washoe, Paiute, and Western Shoshone. On the west side of the Sierra, it is common among the Western Mono, Chukchansi, Choinumne, and Southern Sierra Miwok. There are several similar design features exhibited in these cradles. Each has a rectangular shape, constructed of slender vertical warp rods woven together with several courses of twining. An exception to this is found among the Western Mono and some Owens Valley Paiute, who incorporate horizontal warp rods onto the vertical, resulting in a double back. All include a separate woven hood.

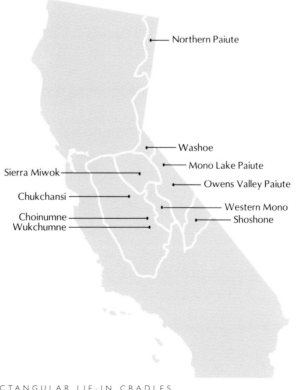

61 RECTANGULAR LIE-IN CRADLES

▲ ▲ ▲ ▲

WESTERN MONO

Receiving Cradle, *pasak*
2000
Francys Sherman (Western
Mono) 1921–2002
Sourberry shoots, buck-
brush shoots, split winter
redbud shoots, yarn, com-
mercial leather
24¾ in. long x 12 in. wide
x 9 in. deep
Marin Museum of the
American Indian

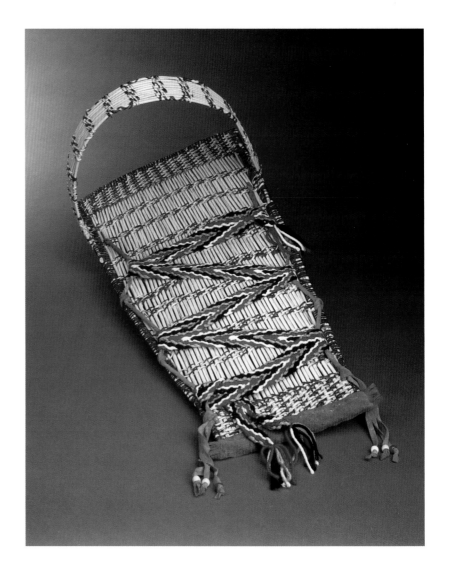

The Western Mono (also referred to as Monache) are a linguistically related people of at least six distinct tribal groups (Nɨm, Wobonuch, Entimbich, Michahay, Waksachi, and Patwisha) occupying three major Sierra watersheds: the San Joaquin, Kings, and Kaweah Rivers. Consequently, there are slight differences in basketry traditions, including cradle design.

The receiving cradle, *pasak,* is usually made before the child is born and therefore does not carry gender-specific patterns on the protective arch. The infant stays in this cradle for about three to four months and then moves into a larger and more substantial cradle known as a *huup.* Three or four successively larger *huups* may be used before the child is walking proficiently and no longer requires one.

Western Mono society is organized into two "sides" within which descent is traced along paternal lines. In anthropological terms, these dual divisions are known as moieties. A child is automatically a member of his or her father's side. One side is represented by Eagle and the other by Coyote; as Nɨm elder Rosalie Bethel explained, "Just like you have a Democrat and a Republican."[1] This form of social organization comes very much into play during the events leading to and following the birth of a child. It determines who makes the basket and what name the child receives, and it illustrates a reciprocal relationship between the new parents' families—and on a larger scale, the two sides. These relationships are fully manifest at events like baby showers, the contemporary term for the gathering at which an infant's naming ceremony (*nipaki*) takes place.

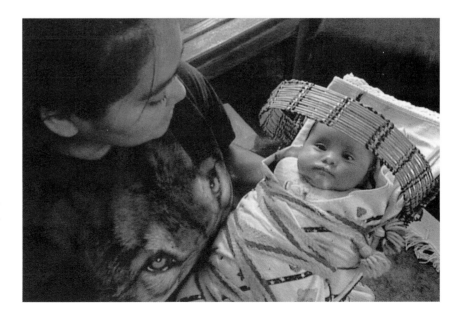

▶ Robin Bethel, with daughter Belinda in a *pasak,* or receiving cradle, North Fork. Still image from video by Michael Anderson, 2003

After giving birth, a new mother was kept quiet and still for about ten days, until the naming ceremony. Francys Sherman recalled her own experiences following the births of her children:

> My mother would count eight days, and I couldn't eat any salt. She wouldn't feed me any salt at all. And they took care of me, they pampered me. Nowadays in the hospital they let you out the next day. Boy, I'll tell you, my mother-in-law and my mother wouldn't let me out for anything. Every child I had, that's how they treated me. On the eighth day I got an Indian baby shower.
>
> The lady that made the *pasak* . . . that would have been my husband's grandmother . . . she would take the baby and pass it through the hoop of the cradle. They pull the baby through the hole. It meant that the next birth I have would be easier. As they do that they say, "We wish this baby wisdom, strength, good health." Also, they usually give it a name. It's named after a person on the father's side . . . always on the father's side.[2]

As a part of this ceremony, the father's family brought a washing basket and new clothes for the baby's mother. They washed her completely, arranged her hair, and dressed her in her new clothes and ornaments.[3]

1. Bethel 1999
2. Sherman 1999
3. Gayton 1948:273

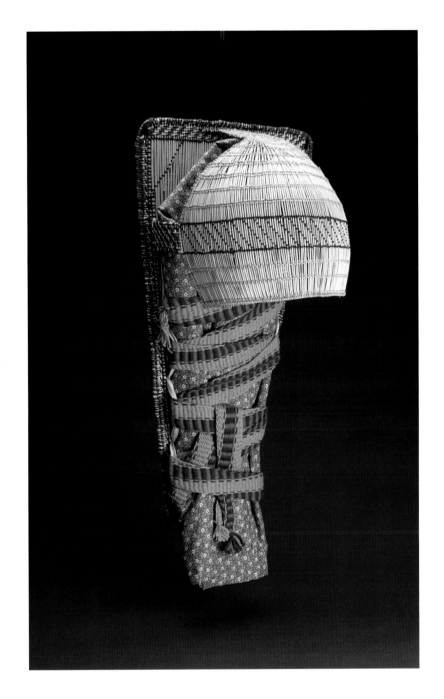

▲ ▲ ▲ ▲

WESTERN MONO

Cradle Basket (*huup*) and
Baby Quilt
Ruby Pomona (Western
Mono), 1925–2001
Sourberry shoots, split
winter redbud, split sedge
roots, chaparral (buck-
brush) shoots, yarn, red
earth pigment, commercial
leather
31 in. long x 14½ in. wide
x 11¾ in. deep,
quilt 34 in. x 34 in.
Marin Museum of the
American Indian

The Western Mono baby's second cradle is a more substantial basket with a full hood. A feature of the cradle's construction is its double layered back: a course of vertically arranged rods on the front interlaced with horizontal rods on the back. This technique may have developed because of the relative weakness of

sourberry shoots (as opposed to willow); a back with two layers of rods arranged in opposing angles provides greater strength.[1]

The Western Mono use four different gender identification patterns, usually wrought in redbud within a band across the front of the hood, and throughout the cradle back. The pattern on the hood's brow actually connects it with the arching strut of chaparral sticks. The pattern on the boy's cradle pictured here is known as "slash." The straight lines are associated with shooting straight, a reference to hopes that a boy will grow up to be a good hunter. The pattern may also be iconic of a bow string, another reference to hunting.

Ruby Pomona recalls that the dried stump of an infant's umbilical cord was bound with string and often put in a small buckskin bag and attached to the hood of the second cradle.[2] Mono elder Rosalie Bethel described how her people eventually disposed of the umbilical cord:

> All my babies' navels (*podji*) went in the San Joaquin River. It's got to be strong, live water. It's not a creek or anything, because that dries up. They take that little navel and tie a rock to it. Then they throw it in the water. The rock carries that little navel down to the bottom. The reason for that is, that little baby will never have fever, because it's cool there all the time. Its bowels will always be flushed because the water keeps it flushed. These are the beliefs. What you believe in strongly becomes reality. We depend upon nature and the creator—very, very strong.[3]

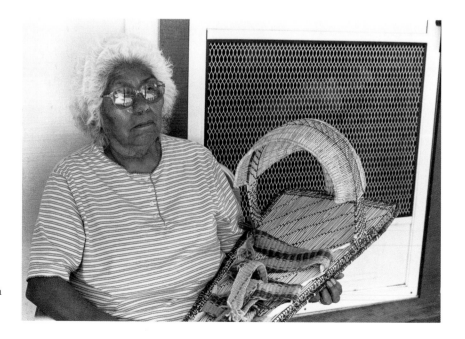

▶ Ruby Pomona. Photograph by Brian Bibby, 2001

The Western Mono had specific ideas on the treatment and disposal of a cradle basket once the child outgrew it. Traditionally, the basket was not to be reused by another child:

> They used to take it and put it on a young pine tree and just let it go. And when the tree grows, the basket would just rot away up there. The reason they did this is because they wanted the baby to grow straight and strong like a pine tree. They didn't believe in using a cradle that was used before. I saw one hanging in a tree when I was young. Now you couldn't do that. There's too many people out there. If somebody saw it they'd climb up the tree and get it.[4]

Because of the cradle's rigid back, a mother would move her infant child's head from side to side periodically. "They usually move its little head and pad it on one side and move it every once in a while," recalled Rosalie Bethel. Without this periodic movement, a flat spot can develop on the back of the child's soft skull. Known as "occipital flattening," this characteristic is not unusual in the archaeological record. Visiting a Sierra Miwok community at Bald Rock (Tuoloumne County) in 1901, John W. Hudson noted, "Occipital flattening very marked in all these old people, and to some degree the younger set. The *hikke,* or hard wood cradle, is the direct cause of this, though it's now obsolete."[5]

Ruby Pomona raised her son Gaylen Lee in a cradle. "My head is round," he joked in an interview. "I'm proud of my mom. In grammar school we used to tease each other, as Indian children: 'Oh, your head's flat in the back. Your momma didn't take care of you!'"[6]

Others mused that they weren't as fortunate as Gaylen. "My mother must have been awful busy," said Rosalie Bethel, "because my head is flat as a pancake in the back. It's right even with my back."[7]

1. Polanich 1999
2. Pomona 2003
3. Bethel 1999
4. Sherman 1999
5. Hudson 1901
6. Lee 2003
7. Bethel 1999

▲ ▲ ▲ ▲

WESTERN MONO

Cradle Basket, *huup*
2001
Gladys McKinney (Western
Mono), 1946–
Sourberry shoots, split
winter redbud, chaparral
(buckbrush) shoots, split
sedge roots, yarn, leather
boot lacing
31½ in. long x 14¼ in.
wide x 11¾ in. deep
Marin Museum of the
American Indian

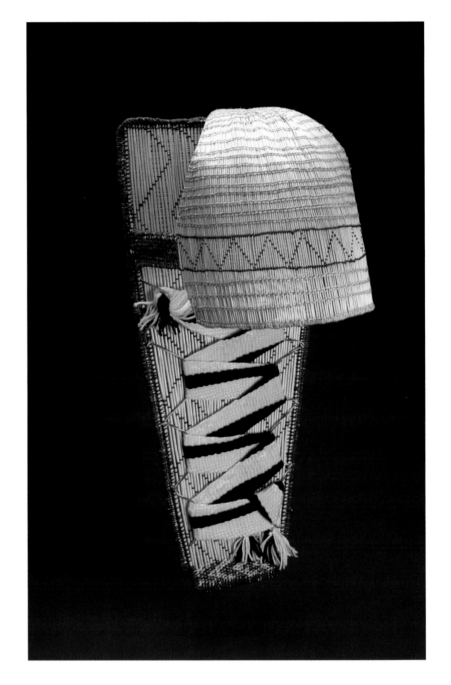

The zigzag design band across the hood and back of this cradle indicates the occupant is a girl. The pattern has been interpreted to represent beauty, meaning the girl should grow up to create beauty—as with her basket making. The cradle hood, as viewed by the baby from the inside, was symbolic of the heavens—"It's like looking up at the Milky Way," Mono elder Francys Sherman once explained.

Gathering basketry materials on a yearly basis is critical to their quality. Weavers "manage" specific groups of shrubs in order to maintain the qualities most desirable for excellent basketry. For weavers of Western Mono cradles, the shoots of sourberry are perhaps the most essential. Western Mono weavers generally collect sourberry in mid-winter, when all the leaves are off.

> You have to know where your bushes are and go down to the same bushes and get them. You have to cut it every year to get your straight sticks—or burn the area, then you'll get more. But if you let it go, then it's no good. It'll start branching out. It's just not any good.[1]

The short, stout shoots of chaparral are used for the arching frame that the hood is attached to. As Mono elder Francys Sherman explained, "Chaparral is springy. And if you were to drop the baby, it [the protective hood] shouldn't break."[2]

1. Sherman 1999
2. Ibid.

▲▲▲▲

WESTERN MONO

Cradle Basket, *huup*
2001
Leona Chepo (Western
Mono), 1931–
Sourberry shoots, split
redbud shoots, buckbrush
shoots, sedge roots, red
earth pigment, leather boot
lacing, yarn, glass and
plastic beads, bells
31 in. long x 15 in. wide x
11 in. deep
Marin Museum of the
American Indian

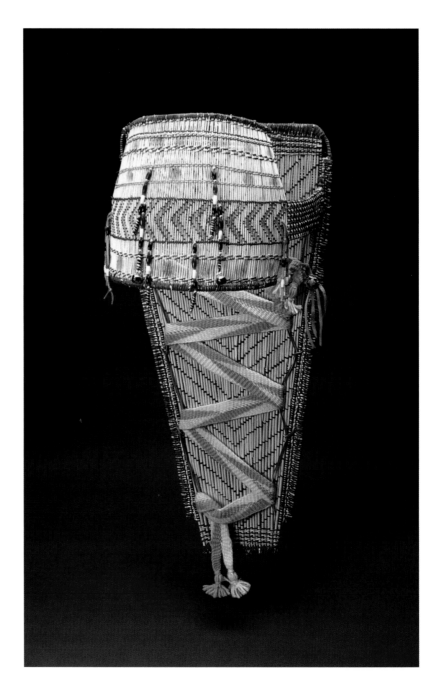

Leona Chepo had not made a *huup* until she became a grandmother. "When my first grandchild was born I asked my mother to make a *huup,*" she says. "She told me rather bluntly, 'You're the grandmother, you make it.'" Thus, with the help and instruction of her mother, Leona made her first *huup*. "I wish I would have learned much earlier. I really enjoy it. I work on my baskets almost every day."[1]

The shape of the hood on Leona Chepo's cradle differs from the previous two examples in that it is not connected to the top end of the cradle back. This hood style is generally attributed to the Northfork-Auberry region of the Nłm. Leona's sister, Betty, finger-weaves the straps for the cradles.

The chevron pattern on this cradle is the other pattern found on Western Mono cradles for boys. The chevrons refer to arrows and, by extension, hunting prowess. Some families used .22 shell casings, drilled through the casing base, in place of freshwater shells and beads to embellish cradle hoods, as an added reference to hunting prowess. The dangling shells also provided a jingling sound for the child's amusement, and the rustling of the dangles when the cradle was rocked gently were felt to help put the baby to sleep. Most

▶ Red earth pigment from Mono County

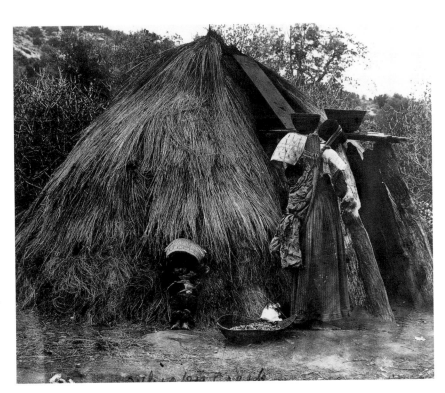

▶ Western Mono home near Whiskey Creek. Photograph by A. W. Peters, ca.1900, courtesy of Jane Edginton Collection, National Park Service, Yosemite Museum. No.19,613.

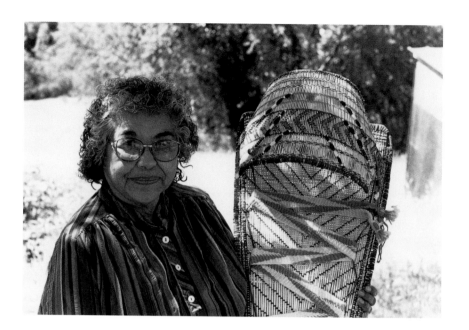

▶ Leona Chepo. Photograph by Brian Bibby, 2001

weavers say that the primary purpose of these ornaments is in the sounds they make, rather than any symbolism in their appearance.

The red dots painted on the hood are made from a pigment that was gathered on the east side of the Sierra. Leona was given a piece of this pigment by her mother, Mary Chepo. "They called this paint *pishop*. It was gathered near Bishop, and I guess they couldn't pronounce Bishop, so they said *pishop*." While there is no standard interpretation for what the red spots on the hood symbolize, Mono elder Francys Sherman indicated they represented the body, the woman's blood.[2]

Personal connections to cultural tradition can manifest in many forms. As she scrapes the bark from her sourberry sticks, Leona's font room is filled with the distinctive, citrus-like aroma of the shoots. *"Hibichi kwana,"* she says with a smile, "smell-like-an-old-lady." It's a synonym for basket makers, a reminder of how the old weavers smelled because of their frequent work with sourberry sticks and the pungent shavings that annointed their clothing.

1. Chepo 2001
2. Sherman 1999

WESTERN MONO

Cradle Basket, *huup*
2001
Lois Jean Conner (Western
Mono/Chukchansi/
Miwok), 1951–
Sourberry shoots, split win-
ter redbud, chaparral
(buckbrush) shoots, split
sedge roots, red earth pig-
ment, yarn, buckskin, glass
beads, bull pine nuts
31¼ in. long x 18 in. wide
x 12½ in. deep
Marin Museum of the
American Indian

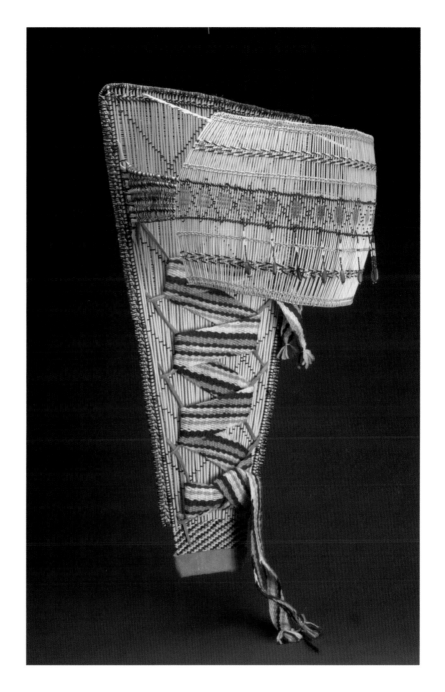

The pattern of diamond-like motifs woven into this cradle's hood indicates the basket is meant for a girl. The Western Mono use a finger-woven sash, attached to the cradle, for cinching the baby onto the cradle. In earlier times these were usually made of native milkweed fiber, but commercial yarn has long been in use.

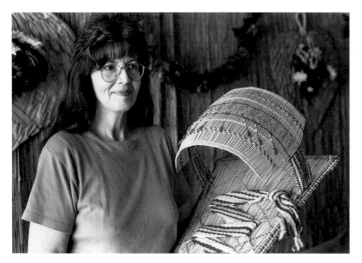

▶ Lois Conner. Photograph
by Brian Bibby, 2001

Right:

▶ Western Mono woman
with baby in cradle near Crane
Valley. Photograph by A. W.
Peters, c.1900, courtesy of
Jane Edginton Collection,
National Park Service,
Yosemite Museum.
No.19,604

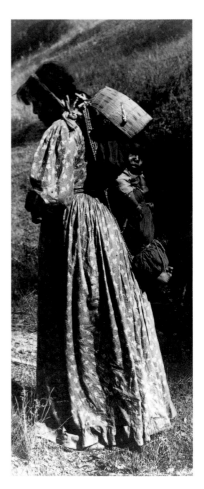

The continued use of the *huup* through-
out the twentieth century is a testament
to its practicality and effectiveness. While
much of Western Mono traditional life
changed or disappeared after the arrival
and settlement of the region by Euro-
Americans, it was still a relatively common
sight well into the 1930s to see Mono women carrying their infants in cradles, on
their backs, in towns like Northfork. Today demand for cradles remains high, and
although few women carry them on their backs, they continue to see them as a
fully functional means of holding and transporting a child.

There are well-established traditions among the Western Mono concerning the
care of infants and the use of cradle baskets that few outside observers are aware
of. Elders such as Rosalie Bethel speak from intimate personal experience on the
subject:

> A lot of people think, "Oh, it's terrible to have a baby wrapped up like that . . . never
> moves or nothing." But I'll tell you, that little baby doesn't stay in there all the time. We
> take it out, feeding time, and lay it down—let it kick and have a little exercise while it's
> nursing. Then when it's tired we put it back in the basket. There, it's well covered and
> kept warm.
>
> For chafing, we got the [deer] bones and mashed it, ground it up and mixed it with

the marrow. They grind that together and use that for chafing like we use baby powder now. That's what they applied on the baby. Also, it's very important that you move its head when the baby is in the basket. . . .

When we carry [the cradle basket], we usually have a strap in the back, and the strap goes around our head, and the baby lays on your back—like when we're traveling a distance, or going out to gather something. That way it leaves both hands free. I carried mine that way. They just look around. Sometimes you let their hands out and they move around. They're happy in there—you never have them crying as long as you're moving."[1]

1. Bethel 1999

▲ ▲ ▲ ▲

CHUKCHANSI/
CHOINUMNE

Cradle Basket, *ahilitch*
1995
Clara Charlie
(Chukchansi/Choinumne),
1929–
Sourberry shoots, split
redbud shoots, sedge roots,
yarn, olivella shells, Job's
tears seeds, glass beads,
commercial buckskin.
31 in. long x 17 in. wide
Collection of Herb and
Peggy Puffer

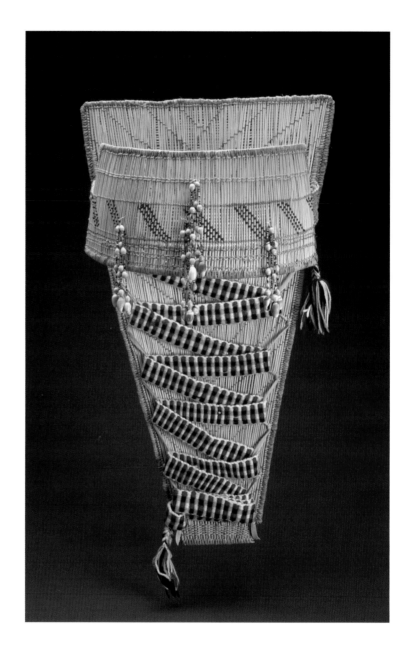

Born on the Table Mountain Rancheria (Madera County), basket maker Clara (Lewis) Charlie is the daughter of Chukchansi and Choinumne parents. She notes that cradles from the two tribes are very similar, the only noticeable difference being the shape of the hood.

The roots of sedge, known as "white root" among Native weavers, are the main material used to weave the cradle together. Favorable growing conditions, especially loose, sandy soil, are critical to the health and quality of the roots. They should be straight, without kinks, and, preferably, long. Clara Charlie's family often dug white roots along the San Joaquin River. She recalls that the sedge bed was located on a small island in the river: "My mother used to braid her hair, and I remember holding on to her braids as we waded across to the island where the white roots were." Wrought in split winter redbud shoots, the design of diagonal slashes on the hood of this piece indicates it was made for a male occupant.

After the initial receiving cradle was outgrown, a Chukchansi baby would generally occupy two or three successively larger cradles. The strap used to secure the baby in the basket was at one time woven with two-ply cordage made from milkweed, but commercial yarn was used throughout much of the twentieth century. When a child is lying horizontally in the basket, the strap is not drawn very tight. However, when the basket is carried upright, as when traveling, the straps are cinched tight enough to restrict movement of any kind. A child was usually kept in a cradle until it could walk or talk.

In traditional times, if a Chukchansi woman experienced difficulty in labor, she might drink a cup of water that contained scrapings from a bear's claw. The decoction could also be rubbed on her head and hands. Parturition is said to have occurred very soon after: it was believed that the bear-claw drink so frightened the infant that it came out at once.[1]

Chukchansi society was patrilineal, and the Chukchansi, like many indigenous peoples, organized themselves according to a system expressing duality, tracing their lineage to one of two moieties. Various bird and animal totems occupied each "side." This social system figured prominently in the events surrounding the birth of a child. It was generally the paternal grandmother who bathed the newborn in water infused with wormwood and made the cradle. She also selected the infant's name, choosing one from the father's side of the family.[2]

At a cleansing ceremony, the new mother sat above a pit of steaming wormwood in order to be well. Both families, maternal and paternal, maintained separate fires and cooking areas in preparation for the feast which followed. A formal exchange of gifts also took place. The maternal relatives covered the new mother's steaming "tent" with cooking baskets and blankets for the husband's mother. After

▶ Nellie Graham and son, Chukchansi, 1922 (photographer unknown), courtesy of Phoebe Hearst Museum of Anthropology, University of California, Berkeley. No. 15–6861

taking her gifts off the tent, the husband's mother replaced them with washing baskets, blankets, money, and meat. The girl's father then took these gifts off the tent and took them to the maternal family's campfire.[3]

The washing basket was an integral part of the cleansing ceremony that followed the birth of a child. It was a symbol of the reciprocal relationship established between two families, confirmed by the infant's arrival. Following her steam bath, the new mother was picked up by her father, carried from the shelter, and placed on the ground outside. A large washing basket was filled with wormwood-infused water, and with a small basket, the husband's mother poured the warm fragrant water over her daughter-in-law to cleanse her.

In addition, other women from the husband's side did the same for the new mother's attendants, who had been in the steaming shelter with her. The husband's mother then presented the washing basket to the wife's mother. A further exchange of gifts was followed by feasting, in which each family ate not their own provisions, but food brought and prepared by their in-laws.[4]

1. Gayton 1948:192
2. Ibid.
3. Ibid., 193
4. Ibid.

▲ ▲ ▲ ▲

WUKCHUMNE

Cradle Mattress
ca. 1925
Wahnomkot (Wukchumne
Yokuts), ca.1873–1964
Tule, cotton string
27 in. long x 12 in. wide
Collection of Herb and
Peggy Puffer

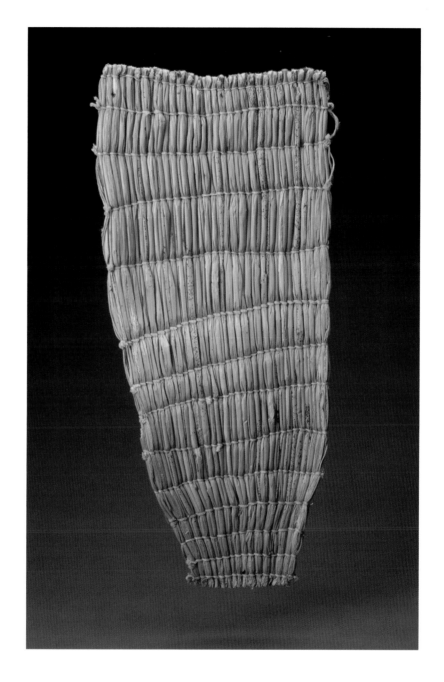

California cradles often included mattresses made of animal fur, loosely
bundled materials such as shredded tule, or soft, inner bark fibers from
cottonwood or dogbane. Wahnomkot (also known as Aida Icho) wove whole
stalks of triangular tule into a mattress to fit the cradle she made for amateur

ethnologist Frank Latta in the early 1920s. The mattress is extremely lightweight, and the tules are surprisingly tough when twined together. The spongy quality of the tule provided a comfortable layer between baby and basket. And though fully dried tule can eventually become fragile, a new mattress can be put together in an hour or two.

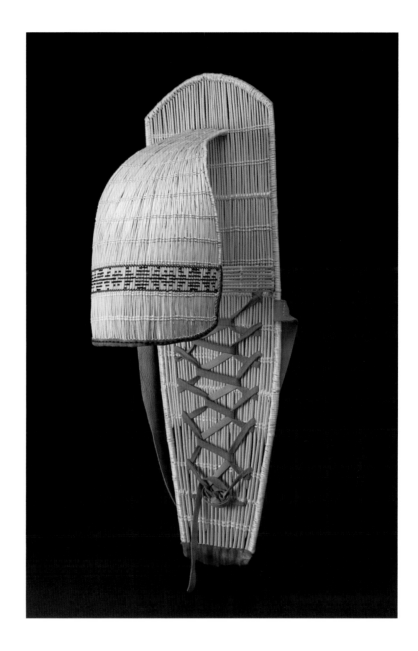

▲ ▲ ▲ ▲

MONO LAKE PAIUTE

Cradle Basket, *huub*
2001
Raymond Andrews (Mono
Lake Paiute) 1949–
Willow shoots, split willow
shoots, embroidery thread,
buckskin, glass beads
36½ in. long x 11¼ in.
wide x 13¼ in. deep
Marin Museum of the
American Indian

The Paiute people living in the vicinity of Mono Lake are known as the Kutzadika, a Paiute term meaning "brine fly pupae eaters" that refers to the harvest of this insect on the lake's shores. Snow-fed streams cascading through narrow but luxurious growths of aspen and alder on the east face of the Sierra Nevada quickly find the flat, arid floor of the Great Basin. Willow thrives along these small streams. The quality of willow in this environment is evident in the

weaving traditions of the Paiute people, as willow is often the only material used to construct the entire cradle basket, serving as both warp and weft.

Traditional gender patterns woven into the cradle hood are diagonal lines for boys and diamonds or zigzags for girls. However, the ornate design on this cradle hood (page 81) does not refer to gender. Raymond Andrews explains, "A neutral design is used when the gender is unknown."[1] The use of fancy, neutral patterns on cradles appears to be partly in response to the expense of purchasing a cradle in today's limited market, as it allows a family to use the cradle for more than one child, regardless of gender.

Raymond Andrews was raised in a cradle made by his grandmother, Minnie McGowan Mike. His route to cradle making, however, began with another craft: "My grandmother and [my] great-aunt, Carrie Bethel, taught me their beading techniques. Then, I guess, they figured I was capable enough to weave, so they guided me." Both Minnie Mike and Carrie Bethel were recognized as among the finest basket weavers of the Western Hemisphere. Raymond recalls that his grandmother was also considered one of the best cradle makers, and that "many people sought her out for expectant mothers."

▶ Raymond Andrews. Photograph by Brian Bibby, 2001

Learning to make a *huub* involved more than construction for Raymond, as his elders also imparted the peripheral knowledge and traditions that link weaving with Paiute attitudes about the nature of the world.

I try to weave as I was taught and follow the taboos that go along with that, like not weaving at night, and not burning the shavings from my willows. I was also told that we should respect the cradle by not playing roughly around it when the baby was in it. I was told not to step over the cradle when a baby was in it, as this might make the baby short when he grew up.

Traditionally, the first five days following birth were viewed as a critical period for the health and future of the baby. The new mother did not touch or scratch herself with her fingernails but used a scratching stick instead. This was a matter of cleanliness. She avoided drinking cold water and meat for a month. The father did not touch his bow, arrows, or gun, and did not engage in hunting or gambling. He ran east every morning and west every evening during this period in order to engender endurance and hunting luck in the child's future.[2]

It is a Paiute tradition to put the infant's dried umbilical stump in a small buckskin pouch and attach it to the basket at the base of the bowed strut connecting the hood. When the baby becomes too large for the basket, the father takes the cradle, with umbilical pouch, and secures it high in a straight-growing yellow

pine tree.[3] Raymond says that his grandmother prayed over the little bundle, then threw it to the west. Mono Lake Paiute elder Della Hern recalls:

> You didn't remove [the] navel when you had a baby in my time. It was placed on there and you had a belly bag. It came off, finally, by itself. You put it in this little sack, and then you tie it onto the basket. That's there until your dad gets ready to place that in a tall tree. And then that way the person is not a scatterbrain. If you lose it . . . I think they call the children "hyper" . . . They say you're looking for your belly button. Nowadays I guess they just throw them away, that's why we have such crazy people.

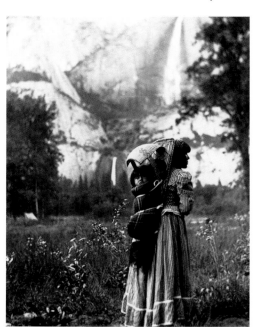

▶ Susie McGowan with daughter, Sadie (Mono Lake Paiute), Yosemite Valley. Photograph by J. T. Boysen, ca.1901, courtesy of National Park Service, Yosemite Museum. No. 18895. Susie McGowan was the great-grandmother of Raymond Andrews.

If a mother had difficulty producing milk for the baby, Raymond explains, a rolled-up piece of rabbit fur was dipped in pine-nut soup, and the baby sucked on this for nourishment.

Both physical and mental health benefits are attributed to traditional cradle use. Raymond notes that Native mothers wouldn't have to worry that an infant secured in a cradle would roll over and smother, as sometimes happens in a crib. "Babies seldom cried, because of the feeling of being held. They slept well. Some would not sleep unless they were in the basket," he observes, recalling how his mother and grandmother strummed the back of the cradle to help put a child to sleep. Periodically, the cradle lacing is undone and the baby's legs and arms are massaged. A mother also moves the infant's head slightly so as to avoid producing a flat spot on the back of the head.

Della Hern recalls the use of cradle baskets during her childhood in the 1930s:

> My brother was a big ol' guy, wearing shoes and stuff, and he'd go get his basket and want to go night-night. Grandma would strap him in there and his feet would be hanging over the end. And he'd go right to sleep, you didn't have to rock him or anything.

"Babies . . . adults now . . . raised in a cradle generally have a good disposition. And they stood straight," says Raymond Andrews. Della Hern also believes that being firmly strapped into a cradle, with movement restricted, has a beneficial effect on a child in the long run: "It helps you in growing up. Maybe it's discipline."

1. All Raymond Andrews quotations: Andrews 2001
2. Steward 1933:290
3. All Della Hern quotations: Hern 1999

▲ ▲ ▲ ▲

WASHOE

Cradle Basket, *bic'oos*
ca. 1930
Maker unknown
Willow shoots, split willow
shoots, buckskin, commer-
cial leather, cotton cloth,
yarn
37¼ in. long x 14½ in.
wide x 11¾ in. deep
Marin Museum of the
American Indian

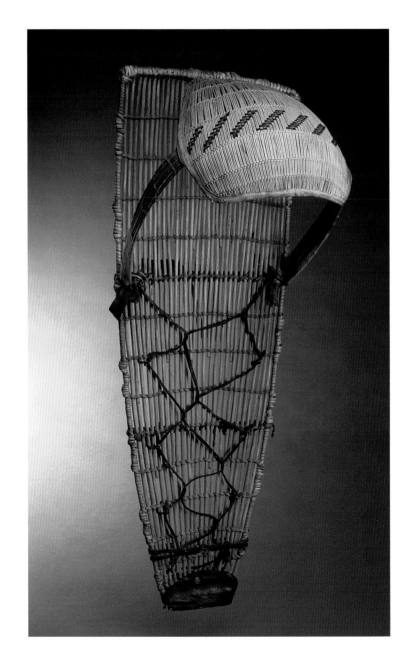

An interesting technical feature found on some Washoe cradles is the use of two different twining techniques: a down-to-the-right slant of twining found on the cradle back (*bic'oos*) and an up-to-the-right slant on the cradle hood (*may-oorup*). Another unusual feature is the use of whole shoots as a weft element on the cradle back: Washoe cradles invariably include two stout willow sticks that run horizontally across the cradle back. The upper of these two helps add support for the carrying strap, which is attached to it. A pattern of diagonal lines on the cradle hood—as with the Western Mono and Mono Lake Paiute—indicates the cradle was made for a boy.

The bottom end of the cradle is generally covered with buckskin or some other available material, such as canvas or another fabric. This helps to protect the bottom of the cradle, which is often in contact with the ground as baby and basket are propped upright. It also prevents the vertical rods from splintering, breaking off, or being eventually pulled apart.

> Hurry up. Crawl Out, I'll see you soon.
> Hurry up. Crawl out, I'll see you soon.
> Hurry out so I can see you.
> For sure that's the way.
> Hurry up, that's the way.
> I'm going to see you.　　　　　—Washoe prayer for health, life, and a quick delivery[1]

In the immediate period following the birth of a child, the Washoe used an oval receiving basket.[2] This may have been the same twined tray generally used for collecting and roasting pine nuts.

The dried stump of the infant's umbilical cord was wrapped in cloth or put in a buckskin bag and attached to the right side of the receiving basket, in the belief that it would make the baby right-handed.[3] When the infant moved into its permanent cradle, the bundle was generally attached to the hood of the basket or tied to the base of the hood strut on the right side. As Washoe basket maker Marie Kizer tells it, "People used to wrap it in a rag or something after it dries, then they put it on there. I don't know why they did that. [Later] my mother used to throw it away." Traditional methods for disposing of the umbilical cord included, for a girl, placing the cord in a hole bored in the root of a living sunflower, and for a boy, placing it in the cavity of a deer femur which was then hung vertically from a tree.[4]

The new father bathed and made gifts of his old clothing and his first kill to members of the community. He also observed the same food restrictions as his wife, abstaining from salt and meat for a period following the birth of their child.[5]

About a month after the birth, the family sponsored a small feast called

▶ Two Washoe women with babies in cradles. Photograph by Smith, 1905, courtesy of California State Parks. No. H–82.

The gender markings on the hood of the cradle at left indicate the occupant is a boy, while the somewhat extravagant pattern on the hood at right, including the diamond motif, identifies the child as a girl. The woman at left has the cradle strap passing over her shoulders, while the woman at right has the strap anchored near the top of her head. Both methods were used and likely alternated when one became tiresome, or to keep the mother's hands free. Also note the draping of cloth and/or blankets over the hood as added protection from the elements, including the hot, bright sun.

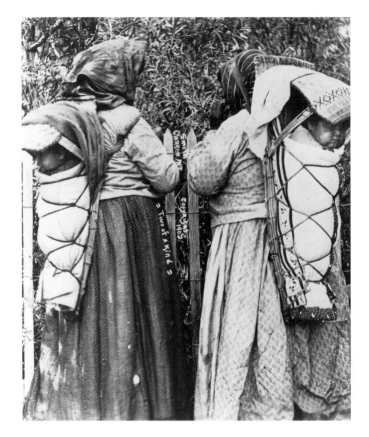

gumga'au. The term means "hair cutting," and during the ceremony both mother and baby had their hair cut. Clippings of the baby's hair were wrapped in buckskin or cloth and attached to the cradle hood. This was also the occasion for the mother's first bathing since delivery.[6]

A female assistant washed the mother by dipping a handful of sagebrush in water, brushing it over the woman's body, and then running her hands over the mother. The receiving basket was then filled with offerings of food and a few valuable items such as a bow, arrows, or an eagle feather. The mother took some of the food, mixed it with sage leaves, chewed the mixture, and then spat it out. The items in the basket were then given away. After this ceremony, the restrictions on salt, meat, and scratching were officially removed.[7]

1. Dangberg 1919:30
2. Downs 1966:43
3. Ibid.
4. Price 1963:99
5. Downs 1966:43; Price 1980; d'Azevedo 1986:486
6. Downs 1966:43
7. Ibid.

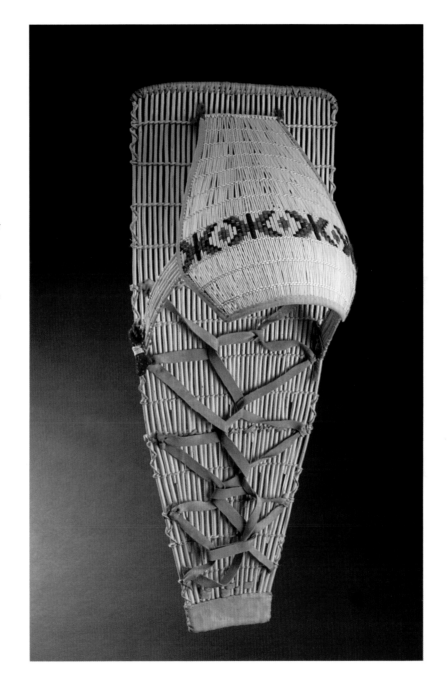

▲ ▲ ▲ ▲

WASHOE

Cradle Basket, *bic'oos*
2001
Marie Simpson Kizer
(Washoe), 1926–
Willow shoots, split willow
shoots, rattan, yarn,
brain-tanned buckskin,
commercial buckskin
33 in. long x 12½ in. wide
x 11½ in. deep
Marin Museum of the
American Indian

Marie Simpson Kizer was born near Tahoma on Lake Tahoe, a traditional summer camping area for the Washoe since pre-European times. Like most Washoe women in the early twentieth century, her mother, aunt, and grandmother (Annie Fillmore) were active basket makers. Marie Kizer recalls:

I used to watch my mother and grandmother make baskets all the time. They go up there [Lake Tahoe] every summer. They had a cabin there where my grandmother used to stay every summer. Used to be called Pomines Lodge then. It's not there anymore. Above the highway we used to have a cabin. They did some laundry for people from the hotel. We had our own tents around the cabin there. They made baskets and my grandma sold it for them.[1]

▶ Washoe woman and child at Lake Tahoe. Photograph by Warren Dickerson, ca. 1930, courtesy of National Park Service, Yosemite Museum. No. RL–14,211

A woman tends to her child's hair while a boy's cradle lies on the ground, a scene reminiscent of Mrs. Kizer's childhood. A model burden basket can be seen in the foreground, typical of baskets made for sale to tourists and collectors at the time.

Right:
▶ Marie Kizer. Photograph by Brian Bibby, 2001

The first baskets Marie learned to make were the small, round, coiled type. It wasn't until later in her life that she began to make the *bic'oos*. Marie recalls that she was encouraged to learn a full range of traditional arts. "My mother used to tell me to try everything that she did."

All of Marie's children were raised in cradle baskets. She carried them on her back, passing the strap around her shoulder, "or you could put it [the strap] on the head too. I used to use old belts [for the strap]." For Marie and her family, the *bic'oos* was a fully functional object. Asked how a baby was situated in a cradle when she was busy at a task, Marie answered, "I stand them up. That's how I used to put mine while I'm working. Then they just watch what's going on."

For the past three decades, Marie's cradle baskets have been in demand by Washoe families desiring to introduce their newest member into the world with style and tradition, as exemplified in the fine work of a Marie Kizer *bic'oos*. Marie Kizer explained that because the cradle shown here (page 87) was commissioned by the Marin Museum of the American Indian for an exhibition and was not intended for either a boy or girl, a neutral design without reference to gender seemed appropriate.

1. All Marie Kizer quotations: Kizer 2001

3 Ladder-Back Cradles

▼ ▼ ▼ ▼ ▼ ▼ ▼ ▼ ▼ ▼ ▼ ▼ ▼ ▼ ▼ ▼ ▼ ▼ ▼ ▼

For the ladder-back style of cradle, horizontal rods or slats are attached to a sturdy frame. It is a simple form, but there are significant variations in the ways that different groups construct it. The Chumash, Valley Yokuts, Serrano, and perhaps other groups in southern California used a sturdy, Y-shaped frame to which stout shoots of willow or some other shrub were attached (see page 99). A modified version of the Y-frame was utilized by all three Maiduan groups (Maidu, Konkow, Nisenan), and later by the Atsugewi. The Ipai, Cahuilla, and Sierra Miwok frame is made of two parallel pieces of wood, while the Mohave, Quechan, and Chemehuevi as well as the Pai Pai and perhaps other groups south of the California-Mexico border employed a hairpin frame.

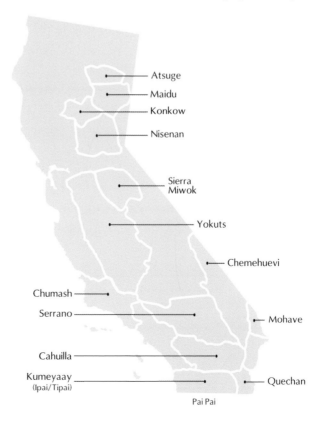

▲ ▲ ▲ ▲

MOHAVE

Cradle Basket,
humadhuvavey
ca. 1925
Maker unknown
Mesquite roots, willow,
arrowweed, cotton,
commercial yarn, feathers
28¾ in. long x 12 in. wide
x 13 in. deep
Marin Museum of the
American Indian

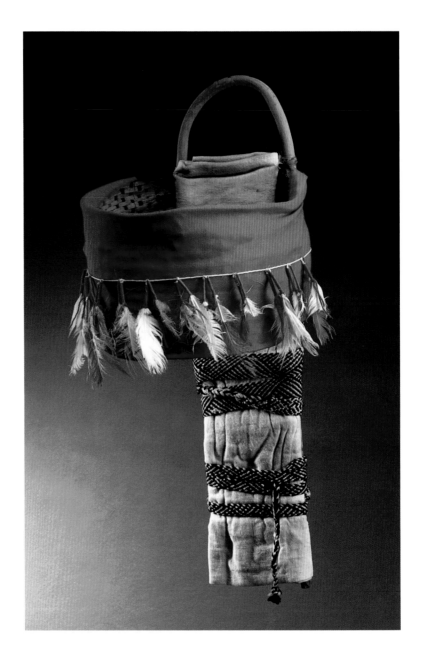

The Mohave cradle, as well as cradles made by the Yuma, Cocopah, and Pai Pai, from the extreme south of California and northern Baja, have a hairpin-shaped frame with several horizontal struts. To this "ladder-back" frame is attached a large, circular hood. Mohave hoods are often woven in a wicker weave, but methods of construction vary. The hoods are often covered with bright red cloth, and those with feathers attached are said to be for boys. The two-color, finger-woven sash carries a maze-like geometric pattern reminiscent of those found on Mohave pottery.

The new Mohave mother refrained from eating any salt or meat for one month after her child was born. Both she and her husband also refrained from smoking during this period.

Twins, *havak,* were believed to possess the gift of clairvoyance and a knowledge of the supernatural. It was said they came from the sky:

> We have only come to visit. Our relatives live above.
> Give us something and we shall stay with you for a time.[1]

It was believed that twins must be treated the same; if one were given more of something, the other would become angry and return to where he had come from. If one died, the other would lie down and, without any outward signs of illness, follow him.[2]

1. Kroeber 1925:748
2. Ibid.

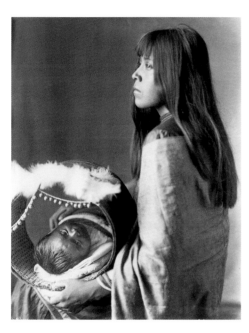

► Rose Emerson and her baby (Quechan). Photograph by Rodman Wanamaker, ca. 1913, courtesy of the American Museum of Natural History. No. 317030

▲ ▲ ▲ ▲

PAI PAI/KUMEYAAY

Cradle, *shpureesh*[1]
2001
Margarita Castro (Pai
Pai/Kumeyaay), 1935–
Willow, yucca fiber, leather
28 in. long x 12 in. wide
x 10 in. deep
Marin Museum of the
American Indian

There are Kumeyaay (Tipai) communities in southern and eastern San Diego County as well as Baja California. Historically, the Kumeyaay resided, hunted, gathered, and attended social and ceremonial events throughout the area now divided by the international border.

Examples of Kumeyaay cradles are rare in museum collections. During the 1920s, a woman living in San Diego County, Owas Hilmana (Rosa Lopez), fashioned small models of traditional Kumeyaay cradles. They are of the same basic form as those made by the Pai Pai, and also, with their hairpin frames and horizontal bars, reminiscent of Mohave and Chemehuevi cradles, except that the type of hood made by Owas Hilmana differs from Margarita Castro's example.[2] Current Pai Pai populations in Baja California include significant Kumeyaay ancestry, as there is a long history of intermarriage between the two communities.[3]

Expectant Kumeyaay women observed prenatal dietary restrictions similar to those of other Native communities in California: they ate bland foods and avoided salt and meat. Kumeyaay informants in the 1950s stated that these foods were not entirely forbidden, but that "one eats less of these things."[4] Similar food restrictions remained in effect for a period after birth, as ingestion of coffee, pepper, or tobacco were said to hurt the child.

After the infant's umbilical cord dried and fell off, it was taken by the midwife and, along with the placenta, secretly buried "so that the coyotes won't eat it."[5]

The new mother was confined to the house for about six days and used a small stick to scratch herself. One explanation offered for this practice was that "the blood is close to the surface and [scratching] will cause one to bleed to death if a sore is opened."[6]

1. Kumeyaay term
2. Farmer 2003
3. Kingery 2003
4. Hohenthal 2001:197
5. Ibid., 198
6. Ibid.

▲ ▲ ▲ ▲
IPAI

Receiving Cradle, *'uukwil*
2000
Justin Farmer (Ipai), 1926–
Willow, scrub oak, com-
mercial deerskin
20½ in. long x 12 in. wide
Marin Museum of the
American Indian

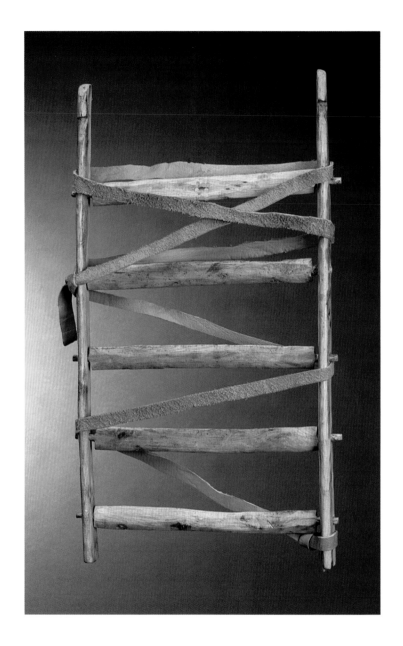

The Ipai are close linguistic cousins of the Kumeyaay (Tipai), and culturally related as well. These two groups, the main populations of the region, were called "Diegueño" by Spanish missionaries of the late eighteenth century, but they self-identify as Ipai (northern division), and Tipai or Kumeyaay (southern division).

Information and documentation regarding cradles from the southern California coastal region are extremely rare. Like most cradles from southern California, the Ipai cradle has a ladder-back form. The wide, airfoil-shaped slats are pegged into the two vertical pieces on this receiving cradle. Subsequent, larger cradles for the Ipai child were most likely ladder-back in style, but they may have employed a hairpin frame of oak or willow and included a wicker-woven visor similar to those found on cradles to the east, as among the Mohave.[1]

Ipai mothers avoided salt, fat, meat, and cold water in the weeks preceding birth and for a brief period afterward. Both parents used scratching sticks. Shortly after giving birth, the new mother lay in a shallow pit lined with sage, "repeating, with fulfillment, her puberty rite."[2] At puberty her girl friends had lain at her side, but this time it was her infant who was beside her.

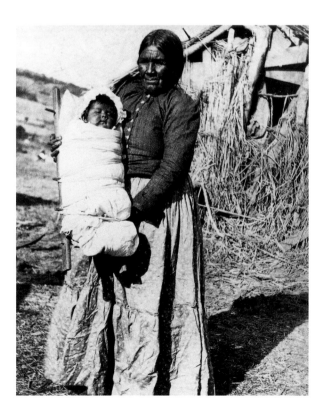

▶ Ipai woman holding child in cradle, Mesa Grande Reservation. Photograph by Edward Davis, ca.1910, courtesy of the San Diego Historical Society. No. OP 15, 362–969.

The puberty rite was more than the commemoration of a physiological change: it also served a major pedagogical purpose. In her autobiography, Delfina Cuero (Ipai) pointed out that it was during the puberty ceremony's several days of important instruction from elder relatives and isolation that the knowledge of how to prepare for children was imparted:

> Grandmothers taught these things about life at the time of a girl's initiation ceremony, when she was about to become a woman. Nobody just talked about these things ever. It was all in the songs and myths that belonged to the ceremony. All that a girl needed to know to be a good wife, and how to have babies and to take care of them, was learned at the ceremony, at the time when a girl became a woman. We were taught about food and herbs and how to make things by our mothers and grandmothers all the time. But only at the ceremony for girls was the proper time to teach the special things women had to know. Nobody just talked about those things, it was all in the songs.[3]

Traditionally, the infant was wrapped in swaddling made of the inner fibers of nettle. Being bound to the cradle was thought to make the growing infant's back straight and strong. In 1910, anthropologist T. T. Waterman observed: "The people say nowadays that all the old men, who are as a rule remarkably hardy, show the advantage of this practice. The younger generation, who are laid in beds and baby buggies and other soft places, grow up round-shouldered, and are not sturdy like the older generation."[4]

1. Farmer 2000
2. Luomala 1978:602
3. Shipek 1970:42–43
4. Waterman 1910:285

▲ ▲ ▲ ▲

CAHUILLA

Carrying Net, *ikut*
1999
Willie Pink
(Cupeño),1950–
Jute twine
31½ in. long
Collection of Herb and
Peggy Puffer

It was often the case in Native cultures that an object might serve a number of different purposes. The Cahuilla wove nets from cordage made of agave fiber to assist them in transporting various burdens—from heavy wooden mortars to small children. The net functioned much as the Spanish-inspired rebozo would, as a sack in which a young child might ride on its mother's back.[1] It is not known for certain whether this custom was established before the arrival of Europeans or if use of the net was inspired by the rebozo. The net also served as a hammock, stretched between house posts, trees, or opposing poles of a ramada, in which the baby might rest or sleep.[2]

1. Hooper 1920:360
2. Kroeber 1925:705

► Maria Luisa (Ipai) carrying child with rebozo. Photograph by Edward Davis, ca. 1920, courtesy of the San Diego Historical Society. No. OP 12550–55

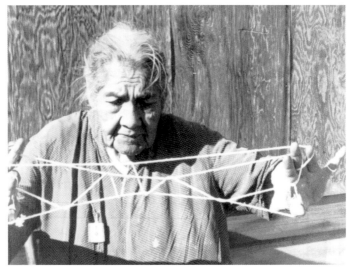

► Mrs. Victoria Weirick (Cahuilla), ca.1960 (photographer unknown), courtesy of the Malki Museum. Mrs. Weirick is shown demonstrating a form of "cat's cradle" to prophesy the gender of an unborn child.

Cradle, *seeyah*
1981
Pauline Murillo
(Serrano/Cahuilla), 1934–
Willow, nylon cord, nails
27½ in. long x 19½ in.
wide
Collection of Justin Farmer

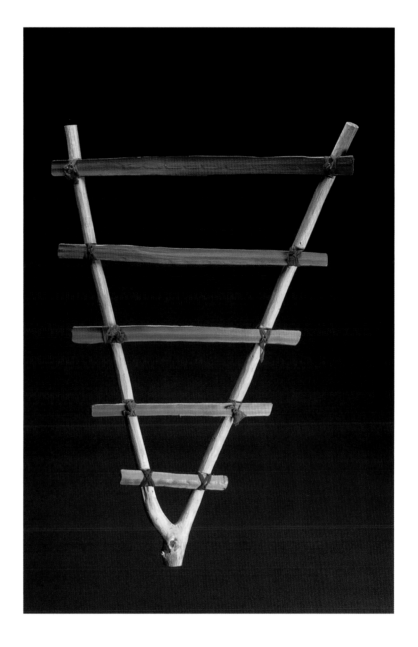

The Y-shaped frame of this cradle is similar to those of the Chumash and San
Joaquin Valley Yokuts. Pauline (Ormego) Murillo explains that the Serrano
made their cradles from a sturdy fork of either willow or the umbrella tree. Al-
though she was raised in a cradle, they had fallen out of use by the time she started
her own family. Through verbal instructions from her mother, she has resurrected
the manufacture and use of the *seeyah*.

Elders in her family stated that children were often taken along, secured in their cradles, while their parents picked fruit in local orchards. The cradle was sometimes suspended from a tree limb and gently pushed like a swing. New parents were advised how to lace the infant in the basket, and warned not to secure the lacing directly across the breasts, stomach, or knees.[1]

The Serrano and Cahuilla adhered to similar dietary precautions during the months preceding birth and for a period of time afterward. Serrano elder Dorothy Ramon stated, "They don't eat deer meat, it's supposed to be bad for them."[2] The expectant Cahuilla woman avoided salt, ate meat sparingly, and drank only warm water, never cold water. She did not eat any portion of the legs of game, for fear that her child would be born feet first. She also avoided seeing anything ugly or defective. "Great stress is placed on the certainty of unfortunate prenatal influence should an expectant mother look at unpleasant or repulsive sights, such as a person marked with sores," wrote western photographer Edward S. Curtis.[3]

A string game similar to "cat's cradle" was sometimes played to predict the coming child's gender. Two patterns were recognized, one associated with each gender. The baby's sex was determined when one of the patterns occurred three times in succession.[4]

It was thought best for a woman to engage in plenty of work while pregnant so that her child would be industrious.[5] "They should also be happy all the time," explained Dorothy Ramon.[6] She also recalled how an infant's navel was fixed if it did not go in properly: "They would take the door of a tarantula hole. Then they would place it on the baby's navel. And so the baby's navel would go in like that."[7]

The new father was expected to avoid salt for a month after his child's birth. He and his wife should not sleep together so long as the baby nursed, else the milk would be spoiled and the child become sickly—a woman who weaned her baby early might be teased by her friends.[8]

Among the Cahuilla, a naming ceremony was held for the child when it reached about four or five years of age.[9] It was a Serrano tradition to formally name, on the fourth day of the annual mourning ceremony, all the children who had been born during the preceding year. Names were selected from the father's lineage.[10]

1. Murillo 2004
2. Ramon & Elliot 2000:39
3. Curtis 1926:29
4. James 1960:61
5. Hooper 1920:350-351
6. Ramon & Elliot 2000:39
7. Ibid., 102-103
8. Hooper 1920:351
9. Bean 1972:61
10. Strong 1929:33

CHUMASH

Cradle Basket, *'uti'nay*
2001
Replica by Kent Christiansen, 1937–
Willow, tule, jute twine, olivella shells
35 in. long x 17½ in. wide x 5 in. deep
Marin Museum of the American Indian

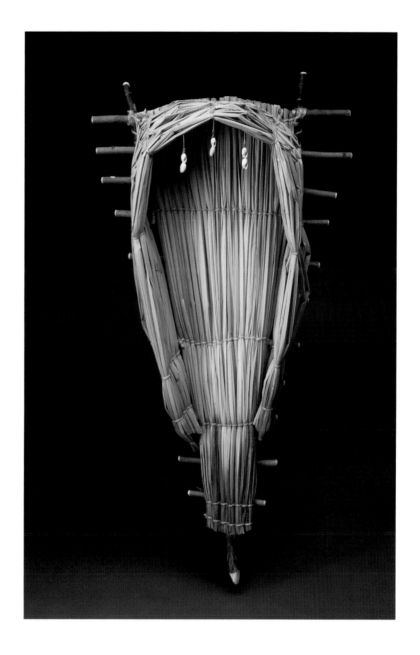

Examples of historic Chumash cradles in American collections are extremely rare, and relatively little is known of their manufacture, regional styles, or the traditions associated with their use.

One of the earliest written references to Chumash cradles is found in the diaries of Lt. Pedro Fages, who passed through the coastal portion of Chumash country in 1769 as a member of the Portolá Expedition, three years before the

establishment of the first Franciscan misson within Chumash territory, at San Luis Obispo. Fages noted:

> The child is then swaddled from the feet to the shoulders with a band to shape its body; thus enveloped, it is fastened against a coffin-shaped board, which the Indian woman carries suspended from her shoulders by cords; she takes the child in her arms without removing it from the frame every time she needs to give it milk, or to soothe it if it cries. Thus the Indian woman is left unencumbered for all their duties and occupations."[1]

Fages also observed mothers flattening the cartilage of their infants' noses by continually pressing or stroking the area with a finger, a practice familiar among other Native Californians as well, and generally attributed to concepts of beauty.

Fernando Librado (1804–1915), the Ventureño Chumash who related much of the knowledge regarding traditional Chumash culture and history that we have today, revealed an interesting nuance of cradle construction. In shaping the base of the cradle's willow-fork frame, he gave it a slight upturn so that the projecting base would be smooth when, as it was carried, it inevitably moved back and forth against the mother's back.[2]

With its pointed base, the cradle could be stuck in the ground, keeping the baby upright. There was an apparent bonus to this practice: a male infant was often provided with an opening in the swaddling for his penis to protrude, so that when he urinated, the liquid would not soil the cradle, its padding, or the swaddling. No such opening was made for female infants. A member of a Spanish expedition to the region during 1791–1792, José Longinos Martínez, noted that Chumash mothers often fed their infants while the cradle was secured in its upright position. "The mother attends to [the infant] and gives it the breast without picking it up, but goes directly to the place where the [cradle] stands."[3]

The 'ut'nay was sometimes suspended from a roof pole so that its base barely touched the ground, and with a little push it could be swung in a side-to-side motion. Librado stated that one did not, however, swing the baby and cradle back and forth.[4]

Within Chumash society there was a certain man who named babies, and had the title of 'alchuklash. He would name a newborn as soon as it moved. It was said the 'alchuklash could judge the destiny of a child, and based on his knowledge of Chumash astrology, he would give the infant a name related to the planet under which it was born.[5]

1. Priestly 1937:49
2. Hudson & Blackburn 1979:318
3. Longinos 1961:56
4. Hudson and Blackburn 1979:321
5. Librado 1977:19; Hudson and Underhay 1978:126

▲ ▲ ▲ ▲

MAIDU

Cradle Basket, *tutum*
2001
Ennis Peck (Maidu), 1948–
Willow shoots, split willow
shoots, black oak, split
winter redbud shoots, pine
roots, buckskin
32¾ in. long x 11¾ in.
wide x 10⅝ in. deep
Marin Museum of the
American Indian

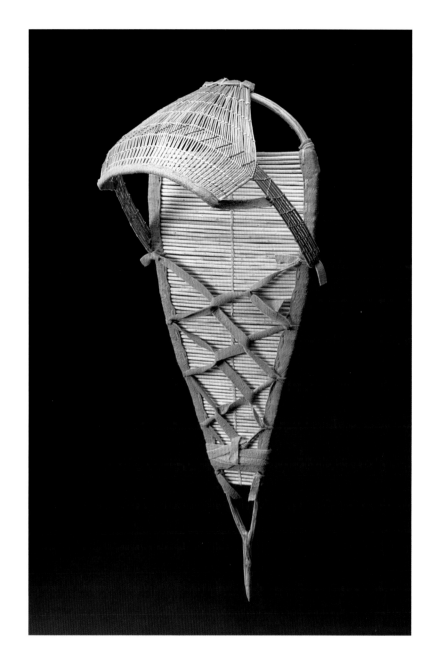

The frames of Maidu cradles are made from forked black-oak branches, which, though they occur naturally, are not always easy to find. Maidu weaver Ennis Peck notes that locating such a fork can take many hours of walking through the woodlands.

The long point at the cradle base could be jammed into the ground, allowing

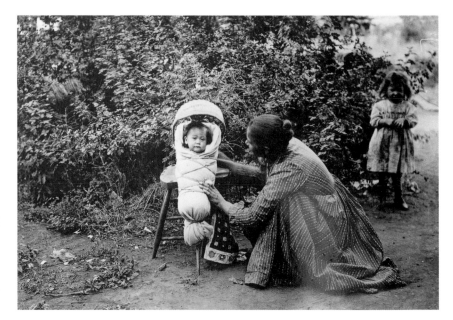

▶ Mary Azbill and son Henry, ca.1900 (Konkow Maidu) (photographer unknown), courtesy of Special Collections, Meriam Library, California State University, Chico. No. SC–4113

the basket to be kept upright while the infant's mother was out gathering foods, or when she stopped to rest while traveling. It was felt the baby would be safer elevated off the ground. The upright child could observe its relatives, keeping entertained and perhaps feeling secure because they were clearly in sight.

Ennis Peck has had an intimate, tactile experience with cradle baskets throughout his life. He was raised in a cradle made by his paternal grandmother, Nellie Peck. As a child he helped gather and prepare her willows. He became an accomplished weaver the way many others have: "I learned by watching my grandmother. You learn best by doing it. You develop a feeling. You just know what to do."

Besides learning the skills required to make baskets, Ennis was also exposed to Maidu traditions associated with cradle use. He recalls how his grandmother blessed a new basket before it was given to a new mother:

> Holding the cradle in one hand, she would talk in her language, blessing the basket. I remember seeing her do that once when I was a child. Then she would give instructions how to wrap the baby in the basket. She showed my mother how to lift the baby up from the back, and how to help it stretch once it was removed from the cradle. They massaged the arms and legs of the baby. That helped the blood to circulate. She also said to move the baby's head periodically, to the left and then to the right, so the back of the head wouldn't get too flat. She would sing to the baby when it was in the cradle. She stroked the cradle back to keep rhythm to her song. The backs of her fingers rolling over the rods worked like a rasp.[1]

1. Peck 1999

Cradle Basket, *wahwasus*
2001
Marlene Montgomery
(Atsuge), 1953–
Chokecherry, willow
shoots, pine roots, com-
mercial deerskin, waxed
cotton lacing
25½ in. long x 13 in. wide
x 11 in. deep
Marin Museum of the
American Indian

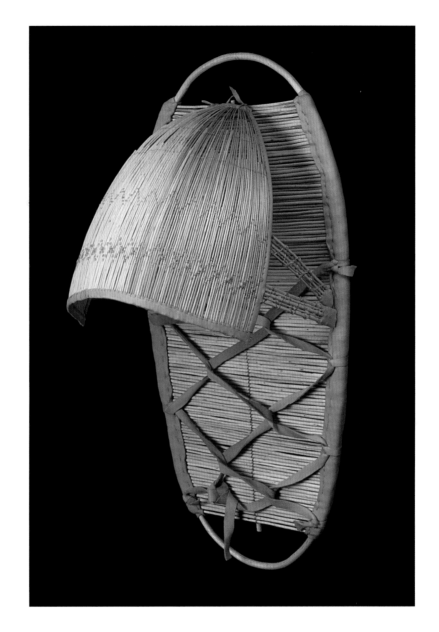

In the past, the frame of an Atsuge baby's second cradle was made from a forked oak branch with a pointed end (identical to Maidu cradle construction), a convenient feature when the mother was traveling or out gathering foods. Atsuge elder and weaver Laverna Jenkins explains:

> They used this kind for traveling, because it had a point on it and the young mother could take her baby in her basket and go out into the fields and dig for her roots or

bulbs, and stick this sharp point in the ground and continue digging. The baby could watch the mother work. In the hot sun, the hood of the basket would help make shade. The baby would cry if it's laying down. But if it's standing up, they think they're being held, because they're strapped in there, and they can look and see what's going on. It's also safer, keeping them away from snakes, lizards, and ants.[1]

The style of cradle presented here represents a change that occurred among some Atsuge in the early twentieth century, as fewer people spent long periods of time gathering traditional foods, and as more people began to travel by automobile. The cradle's pointed stick often caught on the upholstery, tearing it, and the long pointed stick made it hard to fit an upright cradle into the car. The solution was to change the cradle's end to a rounded form, making it more automobile-friendly.

One of Marlene Montgomery's childhood memories is of her mother soaking the chokecherry stave for a long time, then bending and forming it into an oval hoop. The body of the Atsuge cradle has an interesting feature as well: a seat. Marlene explains: "You roll up some buckskin or material and tie it in here like a little seat, so that when you put your baby in there it's not going to slide down."

The back of the Atsuge cradle is made first, and then, after the baby's sex is known, the hood. Among the Atsuge, a V-shaped design is woven into the brow of the hood to indicate a boy, and a diamond pattern for a girl. The hood can easily be attached to the cradle frame using native cordage or buckskin ties.

1. Jenkins 1999

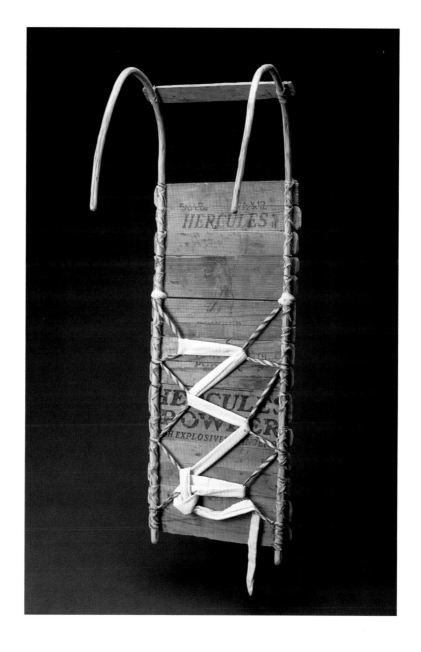

▲ ▲ ▲ ▲

NORTHERN SIERRA
MIWOK

Cradle, *hiki*
2001
Craig Bates, 1952–
Valley oak suckers, split
pine box slats, cotton cloth
(mattress ticking)
Replica of original collected
by Samuel A. Barrett at
West Point in 1906
34 in. long, 11½ in.
diameter
Marin Museum of the
American Indian

This cradle is a replica of one collected by Samuel A. Barrett at West Point (Calaveras County) in 1906.[1] Instead of willow or other native shoots, the back was made of hand-split slats from a Hercules Powder (dynamite) box. It would have been easy for Miwok mothers to obtain discarded powder boxes: well into the twentieth century, in a seeming historic irony, their husbands (Native or non-Native) were often employed in mining operations near their homes in California's gold country.

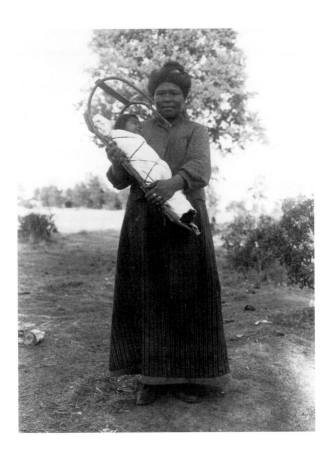

This very unusual cradle style is known only among the Northern and Central Sierra Miwok. It seems to have been largely replaced after the turn of the century by cradles with backs made of sticks arranged vertically and twined hoods, a style familiar among Sierra Miwok communities to the south. It also appears that the Northern and Central Miwok imported Washoe and Paiute cradles and attempted to replicate them.

The close association of an infant with its cradle is exemplified by a Northern Sierra Miwok synonym for infant, or baby: *hikimme,* meaning literally, "one who is of a cradle basket."[2] Northern Sierra Miwok childbirth traditions are similar to those other Native Californians, undertaken as precautions against death or catastrophic health problems following the trauma of childbirth. It was understood that the physical and emotional welfare of mother and child were quite vulnerable during the first few weeks after delivery. The new mother was restricted from eating any meat, grease, or salt for a month after delivery. She avoided drinking cold water. Combing her hair and talking loudly were forbidden for a period of time, and she used scratching sticks, not her fingernails. Two to three months after

her child was born, the restrictions were lifted, following a bath of purification. The new father followed most of the same rules.[3]

When a child shed its first teeth, they were taken to *Səwwətə*, the Pocket Gopher, and carefully put into his hole, ensuring that the second set of teeth would come quickly and grow to be good and strong.[4]

1. Object no. 1-10055, Phoebe Hearst Museum of Anthropology, University of California, Berkeley
2. Callaghan 1987:71
3. Aginsky 1943:436
4. Merriam 1910:210–211

▶ *ossa eseelə*, baby girl pattern (top) and *nanga eseelə*, baby boy pattern (bottom). Photographs by E. W. Gifford, 1923, courtesy of the Phoebe Hearst Museum of Anthropology, University of California, Berkeley. Nos.15–7151 and 15–7150.

Marikita, an aged Miwok woman living in Tuolumne County, demonstrated a variety of cat's-cradle-like string figures, photographed by Gifford. She included forms for a baby boy and baby girl, although it is unclear whether they were meant, as the Cahuilla string figures were, to predict the gender of a coming child.

Cradle Baskets in Central California: Continuity and Change

▼ ▼ ▼ ▼ ▼ ▼ ▼ ▼ ▼ ▼ ▼ ▼ ▼ ▼ ▼ ▼ ▼ ▼ ▼ ▼

by Craig D. Bates

At the time of contact with non-Indians, all of the Native peoples of central California used cradle baskets. Some cradle types could be connected to ancient styles once in vogue outside of California, while others appear to have been unique regional developments, not duplicated elsewhere. Nearly every surviving cradle type would, by the beginning of the twentieth century, make use of introduced materials in their manufacture, alongside indigenous materials. The use of these new materials—commercial cordage, cloth, yarn, or glass beads—often resulted in time-saving devices for Indian women who made the cradles, as well as increased opportunities for artistic experimentation. With the tremendous changes of the nineteenth century and rapid acculturation to western lifestyles, more than half of the central California peoples had abandoned the use of cradle baskets by the mid-twentieth century. Yet some groups continued their ancient cradle basket traditions.

Cradle baskets were a ubiquitous part of native life in Central California. Every individual spent early life in a cradle basket, saw cradle baskets in use throughout life, and likely noticed the often striking differences in cradles made by different tribal groups. Cradles, although occasionally made by men, were primarily the work of women, who also gathered and carefully prepared the plant materials necessary in their manufacture. Women often lavished special attention on the manufacture of cradle baskets. Examination of cradles once used by native people, or those seen in use in historic photographs, generally shows that cradles were carefully and neatly made, and that they adhered to the traditionally accepted style of the maker's people.

Exactly when cradle baskets began to be used in California, and what those cradles once looked like, is unknown. The wet climate of central California is not conducive to the survival of perishable materials, and no cradles are known from an archaeological context; the earliest extant collections of baskets and similar

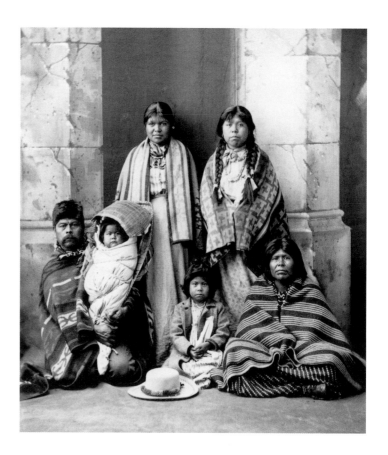

► The Roan Family, Southern Sierra Miwok, 1894. *Left to right:* Jim Roan holding granddaughter Edith, Maria (daughter of Mrs. Roan's sister and Bull Creek Sam), daughter Maggie, Lizzie Roan, and Mrs. Jim Roan. Taken at the San Francisco Midwinter Fair, this photograph shows the Roan family dressed in western clothing. Except for the strings of beads worn by the three girls, the only item of Miwok manufacture is the cradle basket. Photograph by Taber, courtesy of National Park Service, Yosemite Museum. No. YOSE 17,423

materials from the region, made prior to 1870, are devoid of cradle baskets.[1] Photographs and drawings from the first three-quarters of the nineteenth century also show relatively few cradles. Native people themselves seldom kept a child's cradle, and many groups customarily destroyed cradles or allowed them to decay naturally once children had grown out of them.[2] Although there is no tangible archaeological evidence from ancient times, the antiquity of cradle baskets is demonstrated by their widespread use and variety of distinct styles, as well as by their appearance in certain legends.

Several varieties of cradle basket types once existed in central California. These included a double-backed cradle, made by binding a plane of vertical rods to a plane of horizontal rods, used by the Western Mono, Owens Valley Paiute, Panamint Shoshone, and Wukchumne Yokuts; a sitting cradle made of shoots bent into a U form and bound together with cordage in a specialized braid-like weave, used by the Pomo peoples and some of their neighbors, including the Yuki, Wappo, Coast Miwok, and Patwin; a cradle made by lashing rods to a frame that is usually made with a Y-shaped wooden fork—one style with a solid back used by Maidu peoples, and other versions used by the Panamint Shoshone and

some Yokuts peoples; a cradle comprised of two cane-like hooks to which are bound horizontal rods, used only by the Sierra Miwok; and a single-backed cradle comprised of vertical rods held together by spaced rows of twining, used by the Washoe, Sierra Miwok, Chukchansi Yokuts, and Paiute. Other styles, including a tule cradle used by the Ohlone, as well as cradles used by the Esselen and Salinan peoples, did not survive into the twentieth century.[3] The changes in cradle styles and manufacture, and the survival of the use of cradles in central California, differed from place to place, often tied to the disruption and population loss after contact with non-Indians, and to the settlement or relative isolation that was the fate of different tribal groups.

Archaeological evidence exists for only one specific type of cradle basket: the double-backed cradle used by the Western Mono, Owens Valley Paiute, and Panamint Shoshone. The archaeological specimens do not come from California, but from many miles to the east: the ancient Fremont Culture of the Great Basin, and the Anasazi of the American Southwest. As first suggested in the early 1970s by Lawrence E. Dawson, then Senior Museum Anthropologist at what is now the Phoebe Hearst Museum of Anthropology at the University of California, Berkeley, the similarity between the cradle baskets of these ancient people to the east and

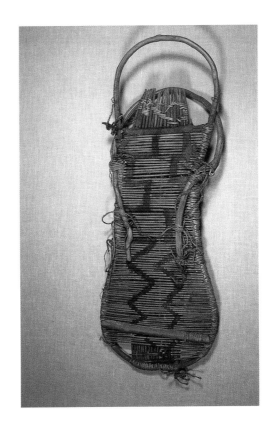

▶ Anasazi cradle frame from Canyon de Chelly, ca. AD 1000–1300(?). This cradle frame is a fine example of the double-backed cradle used by the Anasazi, in which a horizontal plane of rods is bound to a vertical plane of rods using native cordage, in this case of native hemp. 66.0 cm max. length, 25.2 cm max. width. Photograph by Brian Bibby, courtesy of Brooklyn Museum. No. 12484

▶ Western Mono girl in cradle basket, ca. 1900. This unidentified girl was photographed in her cradle near the upper San Joaquin River, on the Stogue Ranch Road. The design on the hood, of connecting diamonds, identifies the cradle's occupant as a girl. The vertical rods on the cradle's back board are clearly visible; the horizontal rods, which would be seen on the back side, cannot be seen here. Photograph by A. W. Peters, courtesy of his granddaughter, Jane Edginton, from the National Park Service, Yosemite Research Library. No. RL–19,616

the historic people of California is so remarkable that it must be more than a coincidence.

The few surviving Anasazi cradles, largely from cliff ruins in northern Arizona and southern Utah, were made by binding peeled or scraped willow shoots horizontally to a more or less oval, bent-shoot frame. To these horizontal rods, a group of vertical rods were individually bound with cordage, often of native hemp or human hair, producing a vertical band of pattern in the center of the cradle. A number of these cradles were recovered in the late nineteenth and early twentieth centuries. They were not found as the result of carefully regulated scientific excavations, and it is therefore difficult to date them; some may be from the later occupation of these sites, AD 1000–1300, while other examples may date as early as AD 500.[4]

The Fremont Culture was, at least in part, derived from people and influences from the American Southwest.[5] Extant cradles from Fremont Culture sites generally lack the oval hoop, and the entire bed of the cradle consists of a plane of horizontal rods bound to a plane of vertical rods. Some of these cradle baskets have

▶ Western Mono boy in cradle basket, ca. 1900. This unidentified boy appears to have outgrown the cradle in which he is photographed. Note the diagonal lines woven across the center of the cradle's hood, indicating the cradle is for a male child. Also notice the faint spots on the hood above and below the band; these marks were painted with red earth. This boy, and the girl in the previous cradle, are both bound into their cradles with strips of commercial cloth. Photograph by A. W. Peters, courtesy of his granddaughter, Jane Edginton, from the National Park Service, Yosemite Research Library. No. RL–19,600

similarly constructed hoods, which form a wide band that would have protected the child's head.

The similarity of this style of Fremont Culture cradle to that used by Western Mono people in historic times is striking. While all Western Mono cradles have the double-plane back board, some of them use a T-shaped hood, while others use a rectangular hood that closely resembles the Fremont Culture cradle basket's hood. Indeed, the "bound weave" used to bind the planes of rods together is the very technique used by Paiute, Washoe, Western Mono, Sierra Miwok, and Maidu peoples to produce the design band in cradle hoods.

How the "bound weave" style of cradle spread, or where and why it originated, may never be known for certain. It may have developed in the Great Basin, where the Fremont Culture's examples of this style are among the most complex. Alternately, it could have developed during the early Basketmaker period of the Anasazi, becoming more complex as time passed, and eventually adopted by the Fremont Culture people. Perhaps the cradle style traveled west, as the Anasazi established their westernmost settlements in southern Nevada, and was adopted by

▶ Wukchumne Yokuts cradle basket made by Maggie "Aida" Icho, ca. 1940(?), of sumac shoots, sedge root, cooked soaproot paste, brain-tanned deerskin, olivella shell beads. This cradle was made for historian Frank F. Latta, who added the shell beads to the cradle's hood. This cradle is identical in construction techniques to those made by the Western Mono, differing only in the use of sedge root, and not split redbud shoots, for all weft materials. Photograph by Michael Dixon, courtesy of National Park Service, Yosemite Museum. No. YOSE 67,849

the ancestors of today's Paiute people. It could have then become a part of Paiute material culture, adopted as the Anasazi villages declined and their residents became absorbed by the Paiute.

In any event, by the time of the earliest documentation for cradle baskets among the Owens Valley Paiute, Panamint Shoshone, and Western Mono, around 1900, the double-back cradle style was in use.[6] The Western Mono probably migrated into their western Sierra Nevada foothill home during the last five hundred years and possibly brought the cradle with them from the Owens Valley.[7] By the early twentieth century, and likely before that time, some of the neighbors of the Western Mono, including the Wukchumne Yokuts, had copied the Western Mono cradle style. Wukchumne women regularly made Western Mono–style cradles,

fancier and more decorative than older Yokuts cradles, and the Mono style may have completely replaced the older form.

The Western Mono rectangular hood and the T-shaped hood used by the Paiute and some Western Mono were both produced in diagonal twining, usually using paired rows spaced an inch or so apart. The design band of the cradle hood was produced in the bound-weave technique, the Western Mono usually using split redbud for the binding material, the Paiute using commercial yarn or strips of cloth. Original cradle designs were usually of two basic types: connecting diamonds or a zigzag, or a band of unconnected, parallel diagonal lines.[8] Designs which connected were used by the Paiute and Western Mono to indicate a female child was in the cradle, while parallel diagonal lines identified a male child. This sex-specific cradle hood was also recognized by the Paiute people north of Owens Valley, as well as by the Washoe, who, like the Mono Lake and Northern Paiute, also produced a T-shaped hood in the same style.

It is remarkable that the double-back cradle type, the one for which the most ancient connections to the past can be suggested, was the cradle that continued to be used and produced in the largest numbers at the end of the twentieth century. Living in a relatively isolated and sparsely populated area of the Sierra Nevada foothills, Western Mono people continued speaking their language and practicing much of their culture on a daily basis long after other groups in central California had ceased to do so. Western Mono women continued making fine examples of cradle baskets throughout the twentieth century, using the materials traditional to their people—sourberry shoots, split redbud shoots, sedge roots, and buckbrush.[9]

During the twentieth century, changes to Western Mono cradles were few. Hoods of cradles might be decorated with glass beads, as they had been since the 1890s, although bead types and the commercial thread used to suspend them changed with the manufacture and availability of these items during the century. The use of cooked soaproot paste to coat the cradle hood, once a relatively common practice, became less and less common as the twentieth century progressed. The soaproot coating made a hard and stiff hood on which bead pendants rattled nicely. However, non-Indian collectors, who were increasingly the most common purchasers of the cradles, did not like what seemed to them an odd yellowish coating. Western Mono weaver Lena Walker (1913–1979) claimed that non-Indians thought the coating looked too much like nasal mucus, and so the coating that had been common in her childhood had been almost entirely abandoned by the 1970s.[10]

The lashings which secured the child in the cradle also changed. A series of

loops on both sides of the cradle, through which a heavier strip of material is laced to secure the infant to the cradle, were apparently originally of brain-tanned deer hide or native cordage. By 1900, these loops were commonly of strips of commercial cloth or boot laces. At that time, the heavier strip of material used to tie the child into the cradle was, judging from photographs taken at that time and extant specimens, a piece of commercial cloth or, less commonly, a loom-woven (warp-face weave) sash of commercial yarn, four or more feet in length. These woven sashes are likely related to the earlier belts and sashes made of native milkweed fiber cordage, which were made more colorful by the substitution of commercial wool yarn.[11] Maggie "Aida" Icho (b. 1878), from the neighboring Wukchumne Yokuts, who made this cradle style, was perhaps one of the very few women who made the straps for cradles of native cordage in the twentieth century. In a series of cradles made for collector and researcher Frank Latta in the 1920s and 1930s, Icho made the carrying straps of native hemp cordage, and the strap for lacing the child in place of native hemp or milkweed cordage. These cradles were apparently made in an idealized pre-contact style for Latta, and they probably reflect an attempt to return to earlier styles, rather than what was being used regularly by Icho's people at that time.[12]

Icho's cradles were beautifully made and, like other Wukchumne cradles, differ from Western Mono cradles in using only sedge root weft strands, eliminating redbud from the cradle. The Wukchumne, living on the lower Kaweah River, were able to obtain redbud only in trade from Indian people living farther upriver. Thus, the manufacture of cradles using only sedge wefts likely reflects the use of locally available materials, with design material such as redbud and bracken fern root, available only through trade, reserved primarily for fancy coiled baskets.[13] Icho also coated her cradles with cooked soaproot paste, stiffening both the back board and hood.

By the 1950s, the binding straps used for lashing children into cradles were virtually always yarn sashes. These sashes were produced either in warp-face weave on a simple bow loom or finger-woven in an array of patterns—including diagonal lines, chevrons, and diamonds.[14] The origin of the finger-woven sash is unclear; similar sashes, made in identical technique, have been made in the Midwest by the Mesquakie (Sauk Fox), Ponca, Omaha, Osage, and neighboring groups since at least the early nineteenth century.[15] How and when this type of sash appeared among the Western Mono is unknown. By the 1970s, acrylic yarn had become the common medium for the manufacture of these sashes, and older women such as Margaret Bobb (ca. 1885–1981) and Lena Walker excelled in their manufacture.

By the 1970s, cradles were still being made by skilled Western Mono women, many of whom had been weaving since their childhood. Other weavers began making cradles at this time, some learning the skill in classes held at the then-new museum established by tribal members, the Sierra Mono Museum in North Fork. In addition to Mono women, a few non-Indian and non-Western Mono Indian women learned to make cradles at these classes. Relatively few of the people in these classes went on to make more than two or three model cradles. Still, Mono women continued to learn to make cradles, and cradles were probably the most commonly produced basketry form among these people in the last quarter of the twentieth century.

A few weavers who were weaving fine cradles during the second half of the twentieth century are of special note. Ida Bishop (ca. 1894–1982) was known for her finely and neatly made cradles, and was one of the oldest practicing weavers at the time of her death. Weaver Ulysses Goode (b. 1927) was one of the very few male weavers. His cradles are remarkable for their attention to detail and his meticulous sorting of material in order to use perfectly matched shoots in the

▶ Susie McGowan and her daughter Sadie, Mono Lake Paiute, in Yosemite Valley, ca. 1901, with Yosemite Falls behind them. The zigzag design on the cradle's hood signifies that the cradle was intended for a girl, and the zigzag pattern on the back board indicates that the cradle was made in a double-warp style. Photograph by J. T. Boysen, courtesy of National Park Service, Yosemite Museum. No. YOSE 18,895

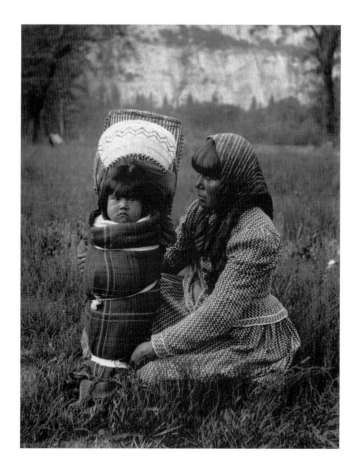

▶ Northern Pomo village at Big River, Mendocino County, 1861. In this rare, early image of a Pomo village, a Pomo infant is playing with its cradle basket. This cradle appears to be made in a twined technique using whole shoots, resulting in a spacing of the warp rods. This is a different technique from other Pomo cradles, which are constructed using a bound weave and cordage, although the shape of the cradle is the same. In the background can be seen a group of Pomo women, one of whom holds a cradle basket of the more common type with its back to the photographer. Photograph by Carleton E. Watkins, courtesy of National Park Service, Yosemite Research Library. No. RL–16,612

Right:

▶ Daisy Mitchell and her daughter, Lena Mitchell, Lake County Pomo, living at the Colusa Rancheria, Yolo County, ca. 1910. Lena is bound into her cradle basket, a fine example of the style of sitting cradle used by the Pomo and their neighbors. Daisy (Lowell) Mitchell (b. 1887) was married to Andy Mitchell, Patwin, of Colusa Rancheria, at the time this photograph was taken. Previously she had been married to Yanta Boone, and later she married Harry Lorenzo. Two of her daughters by Boone and Lorenzo, respectively Mabel McKay (1907–1993) and Frances McDaniel (1919–1990), were famous weavers of Pomo coiled baskets who continued to weave until the late twentieth century. Mitchell's daughter Lena, pictured here in the cradle basket, died as a child. Photographer unknown. From *California and Her Indian Children,* by Cornelia Taber (San Jose: Northern California Indian Association, 1911), 48

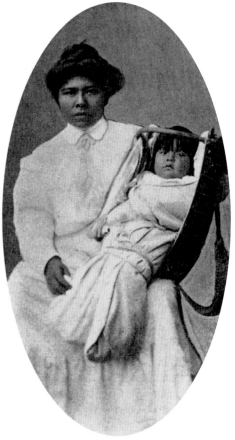

construction of cradle hoods and back boards. Goode's cradles were as fine as any cradle basket ever made by the Western Mono.[16] Goode innovated only in the development of a new hood design on some of his cradles; he developed a technique for producing human figures on the hoods using a bound weave. Boy cradles sported male figures holding hands, while girl cradles used female figures in dresses holding hands. Goode's prototype for these designs was the horizontal bands of linked human figures found on large coiled baskets produced by the neighboring Yokuts. Thus, Goode's adoption of the design was an innovative but highly successful creative experiment, based on a basketry design long used by a group with whom his people shared cultural and social ties.

In Owens Valley, by 1900 the Paiute people who made similar complex double-back cradles were using strips of cloth or commercial cordage to bind their cradle backs together. There is only one extant cradle that is tied together with native material, an example that exhibits black-dyed sinew.[17] Apparently, because of the availability of a wide variety of colors and the relative ease with which they could be acquired and used, cloth and commercial cordage quickly replaced native materials such as sinew or native cordage in binding together cradle backs. The manufacture of native cordage, or plying and staining deer sinew, was time-consuming, and the choice of colors limited. Paiute women were apparently enamored of the opportunity to make new color combinations and patterns afforded by introduced materials. Panamint Shoshone women likewise made cradles using strips of cloth as binding material. Some Paiute women made models of these larger cradles for sale, sometimes making the patterns more complex. The virtuoso Mono Lake Paiute weaver Carrie Bethel (1899–1974) made models of the Owens Valley Paiute cradles, executing complex serrated diamond patterns in yarn on the back boards. By the 1990s, only a few Owens Valley weavers, such as Charlotte Bacoch (b. 1938), were making these cradles. Still using willow rods for the cradle, weavers generally used commercial acrylic yarn as the binding material, often in bright colors such as turquoise and pink. Thus, they continued using introduced materials for the binding material in the manufacture of the cradles, just as their people had done for a century.

The Pomo and some of their neighbors, including the Yuki, Coast Yuki, Coast Miwok, Lake Miwok, and Patwin, made a unique "sitting cradle."[18] The infant sits in the bottom of the U-shaped form, which is bound together with cordage. The antiquity of cradle baskets among the Pomo is demonstrated in their legendary background. Among the Kashaya Pomo, stories of Slug Woman, a mythic figure who abducts humans, always mention her carrying her empty cradle basket. Slug Woman's arrival is heralded by the jangling noise of the abalone shell pendants that completely cover her cradle basket.[19]

The earliest photograph depicting a Pomoan cradle basket was taken in 1862 at a village near Mendocino. The spacing between the cradle's unpeeled shoots is farther apart than in cradles used thirty years later by Pomo people. The earliest cradles collected from Pomoan peoples, during the mid-1870s to 1890s, are made using commercial cordage as the binding material.[20] The availability of commercial string in a variety of sizes was a boon to Pomo women and men (both sexes made cradle baskets among the Pomo).[21] With commercial cordage available, no longer did they have to spend hours gathering native hemp stalks, carefully preparing the fibers, and then rolling the fibers into cordage on their thighs.[22] The selection of shoots used in the cradle's construction varies, with hazel, dogwood, or sumac used or preferred by the various Pomoan peoples in different regions. The ring that is lashed at the top of the cradle, and which protects the infant's head, is usually of oak.[23] Unfortunately, few cradles exist from neighboring groups that also made this cradle style. The few that do, such as those from the Wappo, are virtually indistinguishable from Pomo examples.

There appear to have been three distinct methods of making these cradles, with their characteristic braid-like weave.[24] In all three, the sides and bottom of the U-shaped form are identical; it is with the filling-in of the actual cradle back that different methods are employed. In one style, used by some weavers at the Yokayo Rancheria near Ukiah, the back consists of bent rods in tighter and tighter U forms, fitting inside one another. In the second method, a series of vertical warp rods are trimmed at their base and bent up and over the last of the U-shaped rods from the side walls; these rods are then held in place with a single row of plain twining. In the last method, the back is comprised of a series of vertical rods, as in the second method, but these are simply trimmed at the butt ends to make them thinner, and the trimmed ends are bent to lie inside the U form. The resident infant's butt was protected from the rough ends of the shoots by diapering material and swaddling.[25]

It is likely that each of these forms was specific to different Pomoan groups, but collections are so limited, and often so poorly documented, that this information may never be known with certainty. Similarly, the preference for using different species of plant shoots in the cradles may be linked to environmental factors, and to specific Pomoan communities. The Pomo-Wappo weaver Laura Somersal (1892–1990) preferred creek dogwood for cradles, as did the River Patwin;[26] Elsie Comanche Allen (1899–1990) mentioned creek dogwood, willow, and sumac for cradles,[27] while the Kashaya Pomo favored either dogwood or cream bush shoots.[28] In the 1890s at least some Pomo people at Ukiah used hazel shoots in making baby baskets,[29] as did the Coast Yuki[30] and Coast Miwok.[31] How many of

▶ Cora Azbill, Mechoopda Maidu, ca. 1904. Cora Azbill was the daughter of Mary Kea'a'la Azbill, of Coyongauy Maidu and Hawaiian ancestry, and John Azbill, whose mother was Wailaki and father a non-Indian. The family lived at the Mechoopda village on John Bidwell's Rancho Chico, in present-day Chico. Cora's brother, Henry Azbill, remembered his mother making this cradle basket for his sister. Note the wide design band worked with commercial yarn on the hood of peeled willow shoots. This exceptionally wide design band was apparently a style favored by Mary Azbill. The pointed base of the cradle's forked back board is obscured in this photograph by Cora's blanket. Cora died as a small child. Courtesy of the Dorothy Hill Collection, Meriam Library, Chico State University. No. MS 160:7:11

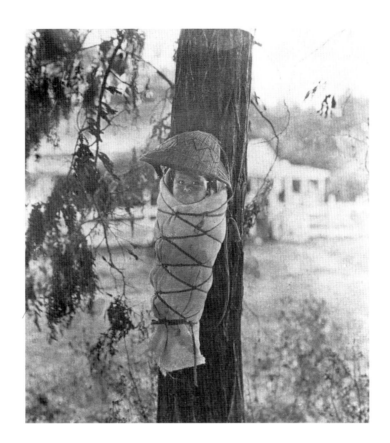

these preferences were linked to specific families or communities, and which might have been linked to changes in environment and settlement patterns in post-contact times, will likely never be known.

Pomo women sometimes made models of cradle baskets for girls to play with, making small wooden dolls to place in the cradles.[32] Occasionally, the Eastern Pomo at Upper Lake created quickly made toy cradles using tule, producing them with plain twining rather than the more laborious bound weave used on lifesize cradles.[33] By the mid-1890s, Pomo women were making models of the larger cradle baskets for sale to non-Indians. While most of these cradles were basically replicas of those commonly in use, some were embellished with glass beads along the bands of cordage weaving, and some were made with beaded straps in lieu of woven tumplines.[34] This type of decorated cradle did not, apparently, become popular among non-Indian collectors, and few examples survived. Throughout the first seventy years of the century, travelers in Pomo country could usually find model cradles for sale, either directly from weavers, from local vendors of Indian material, or, by the 1970s, in antique and secondhand stores. Also during the

1970s, some Pomo weavers making model cradle baskets for sale substituted commercial cane from hobby stores for the rods in the small cradle baskets. By the 1990s, the few Pomo women making model cradles generally used commercial cane in their creations, sometimes using unpeeled willow or other shoots for decorative bands of patterns. Around 1990, a few Pomo women made even more diminutive models, less than an inch in height, which they used as earrings. Thus, with the use of commercial cane and cordage, the cradle models no longer used the older Pomoan materials, but still retained the technology and appearance of traditional Pomo cradles. Although times had changed, and materials changed, some Pomo women kept the cradle and its manufacture as a symbol of identity.

Maidu cradles were of two types, both of which had numerous small rods lashed next to one another on a vertical frame to comprise the back of the cradle. One cradle type's frame was simply a long shoot bent and tied at the bottom into a snowshoe-like form. This form, which lacked any sort of hood, was a common type, and often used indoors during the winter months.[35] The more familiar form was made identically, except that the frame used a naturally occurring Y-forked branch for the base. The bottom of the fork was usually sharpened so that the cradle could be stuck into the ground when out of doors, thus keeping the cradle and child upright.

Generally, but not always, this latter type of cradle had a twined basketry hood, with a decorative design on the bow that held the hood above the baby's face. Among most Maiduan peoples, these hood designs were purely decorative. However, among some of the Mountain Maidu who associated with Paiute peoples, the hood design became sex specific, just as it was among the Paiute. One Konkow cradle, collected before 1910, is festooned with a cluster of deer hooves.[36] The hooves make a pleasant rattling sound, and may be a survivor of an old type of hood decoration. If these hooves once had some sort of significance beyond the rattling sound, it is lost today.

In extant examples made for native use, the shoots which comprise the back board are usually bound with strips of commercial cloth to the forked frame; only a very few are bound with brain-tanned deerskin. Strips of cloth, instead of basket material, were frequently used for the twining on the cradle hood, while commercial yarn or string is found on others. Henry Azbill (ca. 1897–1973), from the village of Mechoopda at Chico, remarked that his mother, Mary Ke'a'ala Azbill (1864–1932), always used cordage on cradles, as she felt that regular basketry weft material was more likely to break, given the nature of the cradle's construction. Azbill himself was raised in a cradle basket; like most children, he received a new cradle as he grew out of the old one. He remembered being told that at the age of three he still would drag his cradle behind him whenever he wanted to take

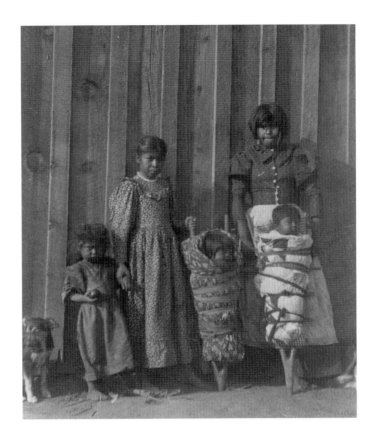

► Yokuts girls and cradles, ca. 1902(?). The exact location where this photograph was taken is unknown; it may be at either the Tule River Reservation or the Santa Rosa Reservation near Lemoore. The heavy, forked frames of these cradles are typical of those made by the Yokuts, Chumash, and Panamint Shoshone. Courtesy of the Grace Hudson Museum and Sun House, City of Ukiah. No. 15163

a nap. Tired of this behavior unbecoming a child of his age, his mother finally burned up his cradle so that he could take his naps like a child, instead of an infant.[37]

Maidu women made use of newly available materials to enhance the appearance of their cradles, or to make them stronger. Some women used wire to replace the sticks used in the bow that supported the hood over the child's face, while others occasionally bound a length of wire around the cradle hood to give it added stability and strength. With the availability of commercial cordage and yarn, women were able to make new hood designs in different colors; Henry Azbill recalled that some women used a pattern from twined basketry, which his mother called "pine cones," as a hood design for a favored daughter's cradle.[38] At least one Mountain Maidu woman carried the idea of twining on cradle hoods to the fullest extent possible, making a cradle hood that was closely twined and overlaid in bear grass and bracken fern root, resembling in both construction and patterning a section of a close-twined burden basket.[39] Occasionally women further enhanced the appearance of cradle hoods with glass seed beads, or with abalone pendants suspended with glass seed beads. As new materials and new types of embellishment

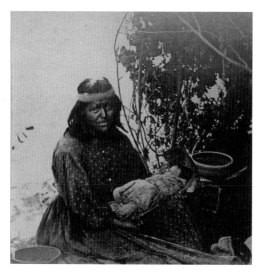

▶ Unidentified Southern Miwok woman and infant, Yosemite Valley, ca. 1867. This is likely the earliest extant photograph of a Miwok woman and child in a cradle. Notice that the child, wrapped in a blanket of commercial cloth, is securely bound into the cradle with strips of cloth. Behind the child can be seen a fine, although unfinished, coiled basket; the rods forming the basket's foundation are projecting out to the side. A portion of the brush shelter, probably made of cottonwood branches, can be seen. Photograph by Carleton E. Watkins, courtesy of National Park Service, Yosemite Research Library. No. Hood 205/11

presented themselves, women took advantage of those opportunities to make cradles more attractive and more sturdy.

During the twentieth century, Maidu peoples used cradle baskets less frequently. Marie Potts (1895–1977), from a village at Big Meadows now inundated by Lake Almanor, made a number of cradle baskets for demonstration purposes, and taught others, including non-Maidu people, how to make cradles in classes held in Sacramento.[40] Maidu weaver Lilly Baker (b. 1910) also taught a few Maidu people to make cradle baskets. At the end of the century, Ennis Peck (b. 1948) was likely the premier weaver of cradle baskets among the Maidu of the Sierra Nevada.

At the village of Mechoopda, located within the city limits of Chico, cradle baskets apparently ceased to be commonly used by the 1920s. With the passing of weavers such as Amanda Wilson (ca. 1865–1946), the knowledge needed to make cradle baskets, as well as other aspects of the culture, was nearly lost. In order to preserve aspects of the traditional culture, some tribal members have been instrumental in attempting to learn skills no longer practiced by their people. To this end, the Mechoopda Tribe of Chico Rancheria held a three-day cradle basket workshop in July 2000. By the end of the workshop attended by more than fifty people, more than thirty cradle baskets ranging from a foot to twenty inches or more in height had been completed. The knowledge of how to create traditional cradles among the Mechoopda was thus reintroduced to tribal members, providing an opportunity for the people to continue to make these baskets in the future.

Other groups used a variation of the Y-fork cradle in which the top of the fork was left open, the frame thus truly resembling a Y. This style was popular among most Yokuts groups, Panamint Shoshone, and Chumash. Among the Yokuts and the Chumash, the forked-cradle frame had a permanent, twined tule mat affixed to the frame, and another, larger one was added when the infant was bound to the cradle. On occasion, a broad band of tules, which had been twined together at intervals of an inch or so, was added to the cradle to form a hood of sorts.[41] This description recalls the only extant old Chumash cradle, which has a band of tules fastened on as an addition, and is said to have been made in the Yokuts style.[42] While the forked cradle was the ancient form among the Wukchumne, Yaudanchi, and other Yokuts groups, it was replaced among these groups, possibly as recently as the late nineteenth century, by the double-backed cradle adopted from the neighboring Western Mono.[43]

The Panamint Shoshone also made this Y-fork cradle, but provided it with a permanent mat of willow rods, or a tule mat like the Yokuts mat. The Panamint Shoshone, however, affixed to the cradle a diagonally-twined basketry hood made of scraped willow rods. The hoods are identical to those used by the Panamint Shoshone on their double-backed cradles.[44]

It was the tragedy of the Sierra Miwok that the principal gold-bearing regions of California lay within their territory. It is likely that, in the second half of the nineteenth century, their numbers were reduced by more than 90 percent. Thus, it is remarkable that Miwok people, and aspects of their culture, survived into the twentieth century. Eastern Miwok cradle baskets of any type are rare in museum collections. Their "hook" cradles, unique to the Miwok and unrelated to cradles produced by any other western North American native group, are the rarer type, uncommon in collections and the historic record. This type of cradle seems to have been used by three of the Eastern Miwok groups. While only one historic specimen, and another in a historic photograph, can be found for the Northern and Plains Miwok, two historic specimens were collected from the Central Miwok.[45] Central Miwok chief Richard Fuller (1893–1977) recalled that when he was a child, this type of cradle was often used for small boys, while another type of cradle, made of vertical warp rods and a basketry hood similar to Washoe and Paiute types, was used for girls. Fuller had been told that when he was a child, his mother had tied a piece of jerky on his wrist while he was bound in a hooked cradle, and that he had chewed and sucked on the jerky while teething.

Miwok "hook" cradles were traditionally made by binding peeled or scraped shoots, horizontally, to the two hooks, producing a solid back board on which to lay the child. The hooks were usually made from tough oak shoots; these were often "sucker" growth, obtained from where an oak tree had fallen down or had been cut down. Four or five loops along each side of the cradle provided a point of attachment through which a broader band would be laced to secure the child in the cradle. Some cradles made around 1900, and at least one made

▶ Lizzie George Wilson (holding cradle), Marion Wilson (in cradle), Alice Roosevelt Wilson (carrying bandanna-wrapped bundle), August 9 or 10, 1920, Yosemite Valley, Indian Field Days, Indian Baby Contest. Lizzie George Wilson, Chukchansi Yokuts, was married to Billy Wilson, a Southern Miwok man. Alice was Billy's daughter by his previous wife, Rosie, who had died when Alice was quite young. Lizzie holds Marion in a typical Chukchansi cradle: note the thick bundle of warp rods forming the selvedge at the top edge of the cradle's back. The hood's diagonal designs usually signified a boy; perhaps the cradle was borrowed or reused for this occasion, when local Indian people entered their children in a contest to win an award for the prettiest Indian baby. Apparently, Marion won first prize in the contest in 1920. Photographer unknown. Courtesy of National Park Service, Yosemite Research Library. No. RL–4433

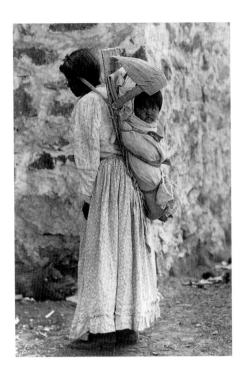

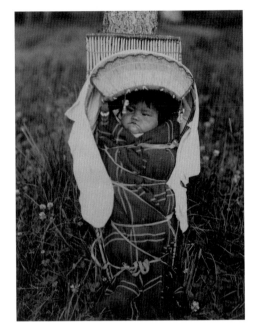

▶ Lena and Virgil Brown, Southern Miwok, ca. 1904. Lena carries Virgil in a cradle basket of Mono Lake Paiute manufacture. Note how Virgil's feet project past the end of the cradle basket, showing that he has either been placed in a too-small, borrowed cradle for this photograph, or that he has outgrown his own cradle. The cradle hood's pattern of diagonal lines indicates it was made for a male child. Photograph by J. T. Boysen, courtesy of National Park Service, Yosemite Museum. No. RL-529

Right:
▶ Unidentifed Washoe child in cradle near Lake Tahoe, ca. 1900(?). This photo shows the straight top of the cradle's back, typical of most Washoe cradle baskets. The cradle's hood sports a fancy two-color band of zigzag pattern, indicating it was made for a girl. The hood is further decorated with a strip of woven beadwork that has been sewn to the lower edge. Draping a piece of commercial fabric over the hood was commonly done to provide further shade for the child's face. Lummis-Dickerson photograph, courtesy of National Park Service, Yosemite Research Library. No. RL-14,214

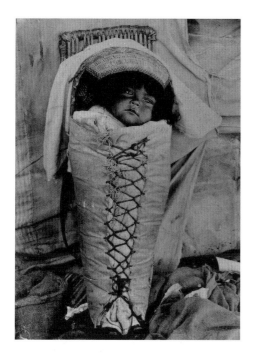

▶ Unidentified Paiute child in cradle, ca. 1940 (?). This cradle is equipped with a cloth sack, provided with loops which are used to lace the child into the cradle. This style of cradle seems to have been popular with Mono Lake Paiute people and some of their northern neighbors in the 1920s to 1950s. Photographer unknown. Courtesy of National Park Service, Yosemite Research Library. No. 46,177

in the mid-1940s by one Northern Miwok woman, utilized thin wooden boards from packing boxes instead of shoots. The availability of new materials resulted in the creation of a changed cradle, but one which still was identifiable as the work of Miwok people.[46]

Sierra Miwok women also made a cradle similar to that of their Paiute neighbors to the east and northeast, and the Chukchansi Yokuts to the south. Made with a back board of vertical rods held in place by evenly spaced rows or paired rows of diagonal twining, the cradle had a finely made hood, also produced in diagonal twining. The earliest photograph of this cradle style was taken in Yosemite Valley in 1868. Some of the finest extant examples of these cradles are from the Southern Miwok, including those made by Ellen Amos (ca. 1853–1933) of Wawona.[47] Most extant Miwok cradles of this type use commercial red wool yarn for the design on the cradle hood bow. Interestingly, in one Southern Miwok legend, the hood of a cradle basket is ornamented with the scarlet scalp feathers of the acorn woodpecker (*Melanerpes formicivorous*).[48] It may be that commercial red wool yarn or red cloth strips were a modern, and easy, replacement for the fine feathers from the woodpecker's scalp. Unlike Paiute and Western Mono cradle hoods, Miwok hood designs did not identify the sex of the child in the cradle.[49]

Chukchansi Yokuts cradles of this same type differ little, if at all, from Southern Miwok examples. The Chukchansi, along with the Western Mono, also made a variant of the single-backed cradle, used as a receiving cradle. The cradle's back board was slightly smaller than that of a full-size cradle, but otherwise the same. However, the full hood was replaced by a simple bow, usually of seven or nine buckbrush rods held together by spaced rows of diagonal twining. These receiving cradles were replaced by larger cradles as the child grew; the single-back type among the Chukchansi, and the double-back type among the Western Mono.[50]

Paiute and Washoe cradle baskets are similar to the Miwok type, and differ primarily in details of the back-board shape, use of plain twining on the back board, and in the shape and placement of warp rods on the cradle hood. A variation on this type, popular in the 1920s to the 1950s, had a cloth sack attached to the back board, into which the infant was laced. In addition to the basic cradle style, the Paiute also produced a fancier cradle which was covered with smoked, brain-tanned deerskin. This type of cradle was made by weaving one nearly identical to the usual Paiute type, which was mounted to an ovoid frame. This was covered

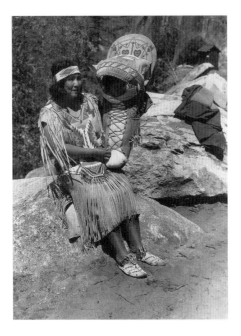

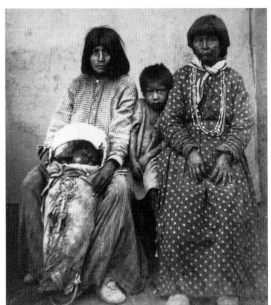

▶ Alice Tom Wilson holding her nephew Carl Dondero in a cradle, Yosemite National Park, 1933. Alice Wilson, of Mono Lake Paiute and Southern Sierra Miwok ancestry, holds a cradle made by either her or her sister, Lucy Telles. The cradle basket was still being used by Telles's descendants in the 1980s. This photograph was taken when Wilson and her nephew were part of a large group of local Indian people who participated in opening ceremonies for the Wawona Tunnel in Yosemite National Park. Courtesy National Park Service, Yosemite Research Library. No. 2107

Right:
▶ Paiute people at Reno, Nevada, 1873–1874. This may be the earliest photograph of a Paiute cradle basket covered with tanned deerskin. This is identical to cradles used by Paiute people living along California's eastern border. Note that the woman on the right wears necklaces of glass beads and olivella shells. Photograph by Carleton E. Watkins, courtesy of National Park Service, Yosemite Research Library. No. RL–16,574

with the tanned deerskin, adorned with fringe, and usually embellished with beaded patterns. It has been suggested by Lawrence E. Dawson that the basic form of the cradle, including the tailoring of the buckskin cover, is based on the cradle used by Plateau groups such as the Umatilla and Shoshoni tribes to the north of the Paiute people living in Nevada. From those Paiute peoples, the deerskin-covered cradle style diffused southward, to Paiute groups as far away as Owens

Valley, California. Examination of Paiute cradles shows that the central seam in the buckskin cover at the top of the cradle, and the placement of the deerskin fringe on the back of the cradle, are identical to those on Plateau cradles. When deerskin-covered cradles were first produced by the Paiute is unknown. However, they were certainly in use at least as early as the 1870s.[51]

Paiute and Washoe women have continued to make cradles throughout the twentieth century, and many women became well known as cradle makers, making them for both Indians and non-Indians. Yosemite/Mono Lake women such as Lucy Tom Parker Telles (ca.1870–1956), and Pyramid Lake Paiute women Katy Frazier and Avis Dunn, are among some of the more well-known cradle makers.[52]

While Paiute and Washoe people continued using cradle baskets, Sierra Miwok people seem to have used them very little by the 1920s and 1930s, and only sporadically throughout the century. One Central/Northern Sierra Miwok family obtained a Washoe cradle from relatives for their newborn son in 1950. The niece of the mother of that child, Dorothy Stanley (1924–1990), although she was not raised in a cradle basket herself and did not raise any of her children in a cradle, arranged for the purchase of Pyramid Lake Paiute cradle baskets for a number of her own grandchildren in 1964, 1978, and 1981. Stanley's pride in her Miwok ancestry led her to obtain what she considered the finest cradles for her grandchildren, made by Paiute women at Pyramid Lake, Nevada, and covered in brain-tanned, smoked deerskin, with beautiful beaded patterns. While no one in the family had made or used a Miwok cradle basket since before 1920, the use of a finely made Paiute cradle was more than an adequate substitute. Its beauty and obvious presence proclaiming that these babies were Indian babies, it was an ever-present symbol and constant reminder of the family's pride in their ancestry.

At the dawning of the twenty-first century, cradle baskets still survive among some groups in central California. Some cradles, such as those made by Western Mono women, are virtually unchanged from those made at the end of the nineteenth century. Cradles from other groups, such as the Ohlone, had disappeared completely. With the tremendous loss of life, land, and culture that the Indian people of central California endured during the previous two hundred years, the survival of cradle baskets into the twenty-first century seems, in many cases, remarkable. At the time of this writing, in 2002, while some native Californians saw no need for cradle baskets in the modern world, others saw them as a tangible link with their culture and ancestors in an increasingly multicultural California.

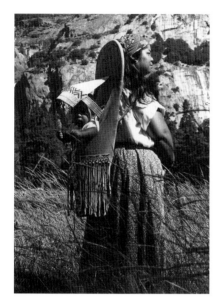

▶ Jennifer Bates and her son, Carson, in Yosemite Valley, summer 1982. Jennifer Bates (Northern Miwok) carries Carson in a Paiute cradle basket made by Avis Dunn from Pyramid Lake, Nevada. Bates's mother, Dorothy Stanley, arranged for the manufacture of the cradle basket for her grandson Carson, just as she had for other grandchildren. Photograph by Michael Dixon, courtesy of Craig D. Bates

Notes

1. For example, the collections made in the 1840s by the Wilkes Exploratory Expedition (Department of Anthropology, Smithsonian Institution) and by Illya Voznesenski (Museum of Anthropology and Ethnology, Museum of Peter the Great, St. Petersburg, Russia), and the late eighteenth-century collection of the Malaspina Expedition (Museo Naval, Madrid, Spain) are among those early collections without cradle baskets.

2. For example, the Western Mono hung a cradle in the branches of a bull pine tree to allow it to decay naturally (Lee 1998:173).

3. See Harrington 1942:24. Researcher Linda Yamane, an Ohlone descendant, has searched for additional information on Ohlone cradles for more than a decade without success (Yamane 2000).

4. Examples of these cradle baskets include Brooklyn Museum catalog numbers 12483 and 12484 from Canyon de Chelly; Museum of Arizona cat. no. 2054; and specimens in the Carbon College Prehistoric Museum, Price, Utah, collections. See also Blackburn and Williamson 1997:95. Unfortunately, studies of Anasazi basketry often do not address this cradle type. See, for example, Morris and Burgh 1941.

5. Marwitt 1986

6. Note should be made of the many photographs of Paiute people in Owens Valley by the photographer Andrew Forbes. Forbes photographed a number of Paiute women with their children in cradle baskets; most of these cradles are of the single-backed variety, such as was popular among the Mono Lake Paiute, rather than the double-backed variety that was popular among the Owens Valley Paiute. Identification of many of these individuals, as recorded at the Eastern California Museum in Independence, California, reveals that the majority of these children in single-backed cradles are pictured with women who are from Mono County, and of Mono Lake Paiute rather than Owens Valley Paiute ancestry. See Bosak 1976 for photographs of some of these women and their children in cradles.

7. Kroeber 1925:580; Polanich 1995:58

8. The Chukchansi and some other Yokuts groups are reported to have differed, in having zigzag or arrowhead patterns for boys, and connecting diamonds for girls (Gayton 1948:188). On sex-specific cradle-hood patterns, see also Kroeber 1925:536; Wheat 1967:101.

9. Western Mono women commonly refer to this plant as "chapparal," a term used by most non-Indians to denote a foothill ecosystem or plant community, rather than this species of ceanothus.

10. Walker 1974

11. See Gayton 1948:65, 84 for a description of these woven sashes. One example of this style of sash, made of milkweed fiber cordage and commercial red wool yarn, was used as a belt by a Chukchansi consultant in the 1940s (Ibid., 65).

12. Two of these cradles are in the collection of the Yosemite Museum, cat. nos. YOSE 67851 and YOSE 67849. For photographs of some of Icho's cradles, see Latta 1977:178, 384, 558, 559, 560.

13. For a description of Icho obtaining redbud in trade, and the difficulty involved in such transactions, see Latta 1977:297–305.

14. It has been suggested that "the bow loom . . . was perhaps diffused through Spanish influence" (Gayton 1948:65).

15. Conn 1963:5–14

16. For a photograph of one of Goode's cradles, see Bibby 1996:73–74.

17. Yosemite Museum, Yosemite National Park, cat. no. YOSE 29014, collected in Owens Valley ca. 1900

18. Callaghan 1978:266; Gifford 1965:63–64; Kroeber 1925:358. Attribution of this type of cradle to the Coast Miwok is based on comments regarding the similarity of Coast Miwok culture to that of the Pomo (Kroeber 1925:275), as well as remarks on Coast Miwok cradles collected from consultants Tom Smith and Maria Copa (Collier and Thalman 1991:156,159, 205, 206, 209).

19. Oswalt 1964:139

20. One of the earliest extant cradles was collected by Stephen Powers in the mid-1870s. It is described and illustrated in Mason 1889:181–182.

21. Chestnut 1902:333

22. Although Barrett (1908:146) mentions that "ordinary weaving fibers are sometimes used" in lieu of string in the construction of cradle baskets, no life-size cradles have been located which use a native material in lieu of string. The only cradle known to the author which does not use commercial cordage is a small model in a private collection. It was made in the 1970s by weaver Salome Alcantra and uses sedge root as the weft material.

23. Goodrich, Lawson and Lawson (1980:52) state that this hoop is also made of wild grapevine (*Vitus californica*). Cradle baskets examined have, as of yet, not located anywhere this material could be identified as the hoop material.

24. This unique style of braid-like weave has been characterized as a variation on bi-weft wrapping with interlacing (Fraser 1989:152–153, Diagram 151).

25. In addition to three styles of cradles, there may have been two methods to produce the braid-like bound weave used to bind the rods together. The most common method, which utilizes one cord to produce the braid, is clearly illustrated in Allen 1972:52–53. Another method, which utilizes two cords, is illustrated in Barrett 1908:279. This two-cord method has not been located in extant cradles examined by the author. For example, a group of Pomo cradle baskets in the Oakland Museum collection all are produced with the single-cord technique (catalog numbers 16–1288, 16–1838, 16–2693, 16–3017, 74.703.109).

26. Kroeber 1932:272

27. Allen 1971; 1972:51; 1973

28. Goodrich et al. 1980:41

29. Chestnut 1902:333

30. Gifford 1965:64

31. Collier and Thalman 1991:159

32. Model cradles with such dolls bound in them can be seen in Barrett 1952:Plate 55, fig. 9; and Fane et al. 1991:205.

33. Fane et al. 1991:206

34. One example of this type of decorated cradle is cat. no. 203527, Smithsonian Institution, National Museum of Natural History, Department of Anthropology. It was collected by J. W. Hudson in 1896 from the "Canel Indians," likely at or near Hopland.

35. Dixon 1905:200

36. This cradle is catalog number IVB 12192, Museum für Volkerkünde, Berlin, Germany, collected before 1910 by Charles Presley Wilcomb from "Nellie's daughter" at Enterprise.

37. Azbill 1970

38. Ibid.

39. This cradle basket is cat. no. 5877, Buffalo Museum of Science and Industry, Buffalo, New York.

40. See Brown n.d.:70 for an example of a cradle made in one of these classes by a Cherokee woman, Judy Six.

41. Gayton 1948:86–87. This description seems to match an illustration of a cradle in Powers 1877:Figure 24. Powers does not discuss this cradle, nor does he identify it as to tribal group.

42. Craig 1966:203–205; Hudson and Blackburn 1982:316–323

43. Gayton 1948:87

44. Examples of these forked, hooded Panamint Shoshone cradles include one by Mamie Joaquin Button (Cleveland Museum of Natural History, Anna Kelley collection number 24) and another collected in 1908 (Peabody Museum of Archaeology and Ethnology, Harvard University, catalog number 10/72985).

45. These cradles are catalog numbers 70237 and 70728, Field Museum of Natural History, Chicago, and catalog number 1–10259, Phoebe Hearst Museum of Anthropology, University of California, Berkeley.

46. The manufacture of these cradles may have ceased in mid-century, although in the late 1970s and early 1980s the author and Jennifer Bates (b. 1951), Northern Miwok, produced several models and lifesize examples based on museum specimens. See Pacific Western Traders 1978:2 for an example of one of these cradles.

47. For a photograph of a cradle by Ellen Amos, see Bates and Lee 1990:132.

48. Latta 1936:130–131

49. Fuller 1970; Stanley 1972; Wessell 1970. Barrett and Gifford (1933:235) describe hood designs, copied from the Mono and Washoe, which indicate the sex of the infant. They then go on to state that "the hoods of true Miwok cradles gave no indication of the sex of the baby." This latter statement concurs with Miwok consultants who stated that the Paiutes and Washoe had this practice, but that the Miwok did not.

50. Gayton 1948:188, 273

51. Stephen Powers collected such a cradle in the early 1870s at Pyramid Lake, Nevada. See Mason 1889:188–189 for an illustration and discussion of this cradle. Mason mistakenly identifies it as Ute, but gives the location of collection correctly. In his discussion of the cradle, Mason noted the similarity of the cradle's cover to that used by the Spokane, a Plateau group.

52. For photographs of Dunn and Frazier's cradles see Fulkerson 1995:46–50; Wheat 1967:99–102. For Telles, see Bates and Lee 1990:118, 119.

Common Names and Latin Names of Basketry Plants

▼ ▼ ▼ ▼ ▼ ▼ ▼ ▼ ▼ ▼ ▼ ▼ ▼ ▼ ▼ ▼ ▼ ▼ ▼

Agave	*Agave deserti*
Angelica	*Lomatium* spp.
Arrowweed	*Pluchea sericea*
Bear grass	*Xerophyllum tenax*
Black oak	*Quercus kelloggii*
Buckbrush (chaparral)	*Ceanothus cuneatus*
Bull pine	*Pinus sabiniana*
Chaparral (buckbrush)	*Ceanothus cuneatus*
Chokecherry	*Prunus demissa*
Cottonwood	*Populus fremontii*
Cream bush	*Holodiscu discolor*
Dogbane	*Apocynum cannabinum*
Dogwood	*Cornus stolonifera*
Douglas fir	*Pseudotsuga menziesii*
Hazel	*Corylus californica*
Live oak	*Quercus wislizenii*
Manzanita	*Arctostaphylos* spp.
Mesquite	*Prosopis glandulosa*
Milkweed	*Asclepias cordifolia*
Nettle	*Urtica* spp.
Redbud	*Cercis occidentalis*
Sagebrush	*Artemesia tridentata*
Scrub oak	*Quercus dumosa*
Sedge	*Carex* spp.
Skunkbush	*Rhus trilobata*
Sourberry	*Rhus trilobata*
Sugar pine	*Pinus lambertiana*

Sumac	*Rhus trilobata*
Tule	*Scirpus* spp.
Valley oak	*Quercus lobata*
Willow	*Salix* spp.
Wormwood	*Artemisia douglasiana*

Sources

▼ ▼ ▼ ▼ ▼ ▼ ▼ ▼ ▼ ▼ ▼ ▼ ▼ ▼ ▼ ▼ ▼ ▼ ▼ ▼

Aginsky, B. W.

1943　　*Culture Element Distributions: XXIV, Central Sierra.* University of California Anthropological Records 8 (4) (Berkeley: University of California Press)

Allen, Elsie

1971　　Personal communication with Craig D. Bates

1972　　*Pomo Basketmaking: A Supreme Art for the Weaver* (Healdsburg, Calif.: Naturegraph Publishers)

1973　　Personal communication with Marion Steinbach

Andrews, Raymond

2001　　Interview with Raymond Andrews, June 8. Document in possession of Brian Bibby

Anthony, Joseph

1908　　"Small Things in the Yosemite," *Out West* 29(1):53–59

Azbill, Henry K.

1970　　Personal communication with Craig D. Bates

Barrett, S. A.

1908　　*Pomo Indian Basketry.* University of California Publications in American Archaeology and Ethnology 7(3) (Berkeley: University of California Press)

1952　　*Material Aspects of Pomo Culture.* Milwaukee Public Museum Bulletin 20:2 (Milwaukee: Milwaukee Public Museum)

Barrett, S. A. and E. W. Gifford

1933　　*Miwok Material Culture.* Milwaukee Public Museum Bulletin 2(4) (Milwaukee: Milwaukee Public Museum)

Bates, Craig D.

1999　　Personal communication with Brian Bibby

Bates, Craig D. and Martha J. Lee

1990 *Tradition and Innovation: A Basket History of the Indian People of the Yosemite–Mono Lake Area* (Yosemite National Park: Yosemite Association)

Bean, Lowell

1972 *Mukat's People: The Cahuilla Indians of Southern California* (Berkeley and Los Angeles: University of California Press)

Bethel, Rosalie

1999 Interview with Rosalie Bethel by Brian Bibby, May 10. Audiotape and transcript on file at Marin Museum of the American Indian, Novato

Bibby, Brian

1996 *The Fine Art of California Indian Basketry* (Sacramento: Heyday Books and Crocker Art Museum)

Billy, Susan

2000 Personal communication with Brian Bibby

Blackburn, Fred M. and Ray A. Williamson

1997 *Cowboys and Cave Dwellers: Basketmaker Archaeology in Utah's Grand Gulch* (Santa Fe: School of American Research Press)

Bommelyn, Loren

2001 Interview with Loren Bommelyn by Brian Bibby, July 12. Audiotape and transcript on file at Marin Museum of the American Indian, Novato

2003 Interview with Loren Bommelyn by Terry Strauss, November 2. Video on file at Marin Museum of the American Indian, Novato

Bosak, Jon

1976 "Andrew A. Forbes—Photographs of the Owens Valley Paiute." *Journal of California Anthropology* 2(1):38–59

Brown, Governor Edmund G. Jr., Presented by

n.d. *I Am These People: Native American Art Exhibit* (no publisher or place of publication listed)

Callaghan, Catherine A.

1978 "Lake Miwok." In *Handbook of North American Indians,* William C. Sturtevant, gen. ed., vol. 8 (Washington, D.C.: Smithsonian Institution)

1987 *Northern Sierra Miwok Dictionary.* University of California Publications in Linguistics, 110 (Berkeley: University of California Press)

Chepo, Leona

2001 Personal communication with Brian Bibby

2003 Interview with Leona Chepo by Terry Strauss, December 3. Video on file at Marin Museum of the American Indian, Novato

Chestnut, V. K.

1902 "Plants Used by the Indians of Mendocino County, California." *Contributions of the U.S. National Herbarium* 7(3):294–408

Clark, Jenny

2002 Personal communication with Brian Bibby

Collier, Mary E. T. and Sylvia Barker Thalman

1991 *Interviews with Tom Smith and Maria Copa: Isabel Kelly's Ethnographic Notes on the Coast Miwok Indians of Marin and Southern Sonoma Counties, California.* MAPOM Occasional Papers Number 6 (San Rafael, California: Miwok Archaeological Preserve of Marin)

Conn, Dick

1963 "Braided Sashes, Part I." *American Indian Tradition* 9(1):5–14

Cook, Sherburne F.

1955 *The Epidemic of 1830–1833 in California and Oregon.* University of California Publications in American Archaeology and Ethnology 43(3). (Berkeley: University of California Press)

1978 Historical Demography. *Handbook of the North American Indians, Volume 8: California.* Robert F. Heizer, ed. Washington: Smithsonian Institution

Craig, Steve

1966 *Ethnographic Notes on the Construction of Ventureño Chumash Baskets, from the Ethnographic and Linguistic Field Notes of John P. Harrington.* Annual Reports of the University of California Archaeological Survey 8:197–214. (Los Angeles: University of California Press)

Culin, Stewart

1906 "Report on a Collecting Expedition among the Indians of Arizona and California (August–October, 1906)." Culin Archives, The Brooklyn Museum

1907 "Report on a Collecting Expedition among the Indians of New Mexico and California, May 4–September 29, 1907." Culin Archives, The Brooklyn Museum

Curtis, Edward S.

1926 *The North American Indian,* vol. 15 (Norwood, Mass.: Plimpton Press)

Dangberg, Grace

1918–22 Fieldnotes on the Washoe. Special Collections Department, University of Nevada, Reno, Library (Warren L. d'Azevedo Collection)

d'Azevedo, Warren L.

1986 "Washoe." In *Handbook of the North American Indians,* William C. Sturtevant, gen. ed., vol. 11 (Washington, D. C.: Smithsonian Institution)

Dixon, Roland B.

1903 Sierra Miwok field notes, on file at the Yosemite Musem, Yosemite National Park

1905 *The Northern Maidu.* Bulletin of the American Museum of Natural History 17(3) (New York: American Museum of Natural History)

1907 *The Shasta.* Bulletin of the American Museum of Natural History 17(5) (New York: American Museum of Natural History)

Downs, James F.

1966 *The Two Worlds of the Washo, an Indian Tribe of California and Nevada* (New York: Holt, Rinehart and Winston)

DuBois, Cora

1935 *Wintu Ethnography* (University of California Publications in American Archaeology and Ethnology 36(1) (Berkeley: University of California Press)

Fane, Diana, Ira Jackness and Lise M. Breen

1991 *Objects of Myth and Memory: American Indian Art at the Brooklyn Museum* (Brooklyn: The Brooklyn Museum)

Farmer, Justin

2000 Letter to Brian Bibby, October 10

2003 Personal communication with Brian Bibby

Fenenga, Franklin

1977 "An Early Account of a Fired Clay Anthropomorphic Figurine from Marin County." *Journal of California Anthropology* 4(2):308–310

Foster, George M.

1944 *A Summary of Yuki Culture.* University of California Anthropological Records 5(3) (Berkeley: University of California Press)

Fraser, David W.

1989 *A Guide to Weft Twining and Related Structures with Interacting Wefts* (Philadelphia: University of Pennsylvania Press)

Fulkerson, Mary Lee

1995 *Weavers of Tradition and Beauty: Basketmakers of the Great Basin* (Reno and Las Vegas: University of Nevada Press)

Fuller, Richard

1970 Personal communication with Craig D. Bates

Gayton, Anna H.

1948 *Yokuts and Western Mono Ethnography,* University of California Anthropological Records 10 (1–2) (Berkeley: University of California Press)

Gifford, E. W.

1965 *The Coast Yuki.* Sacramento Anthropological Society Paper 2 (Sacramento: Sacramento State College)

Goddard, Pliny Earle

1903 *Life and Culture of the Hupa.* University of California Publications in American Archaeology and Ethnology 1(1):1–88 (Berkeley: University of California Press)

1904 *Hupa Texts,* University of California Publications in American Archaeology and Ethnology 1(2) (Berkeley: University of California Press)

Goerke, Elizabeth B. and Frances A. Davidson

1975 "Baked Clay Figurines of Marin County." *Journal of New World Archaeology* 1(2):9–21

Goode, Uly

1999 Interview with Uly Goode by Brian Bibby, May 10. Audiotape and transcript on file at Marin Museum of the American Indian, Novato

Goodrich, Jennie, Claudia Lawson, and Vanna Parrish Lawson

1980 *Kashaya Pomo Plants* (Los Angeles: American Indian Studies Center, University of California)

Hailstone, Vivien

1999 Interview with Vivien Hailstone by Brian Bibby, June 18. Audiotape and transcript on file at Marin Museum of the American Indian, Novato

Haine, J. J. F.

1959 "A Belgian in the Gold Rush: California Indians: A Memoir by Dr. J. J. F. Haine," Jan Albert Goris trans., *California Historical Society Quarterly* 38(2):141–155

Hamilton, Christine

2003 Interview with Christine Hamilton by Terry Strauss. Video on file at Marin Museum of the American Indian, Novato.

Harrington, John P.

1942 *Culture Element Distributions: XIX Central California Coast.* University of California Anthropological Records 7(1):1–46 (Berkeley: University of California Press)

1977 *Eye of the Flute: Chumash Traditional History and Ritual As Told by Fernando Librado Kitsepawit to John Harrington* (Santa Barbara: Santa Barbara Museum of Natural History)

Hern, Della

1999 Interview with Della Hern by Brian Bibby, May12. Audiotape and transcript on file at Marin Museum of the American Indian, Novato

Hohenthal Jr., William D.
2001 *Tipai Ethnographic Notes: A Baja California Indian Community at Mid-Century.*
 (Novato: Ballena Press)

Hooper, Lucile
1920 *The Cahuilla Indians.* University of California Publications in American Archae-
 ology and Ethnology 16(6), (Berkeley: University of California Press)

Hudson, John W.
n.d. [Unpublished manuscript, "Childbirth"] The Sun House, Archive Collection,
 City of Ukiah
1901 Field notebook for 1901. Accession No. 20007. The Sun House, Archive Col-
 lection, City of Ukiah
1902 Field notebook for 1902.\ Accession No. 20010. The Sun House, Archive Col-
 lection, City of Ukiah

Hudson, Travis and Thomas C. Blackburn
1979 *The Material Culture of the Chumash Interaction Sphere* (Los Altos, Calif.: Ballena
 Press and Santa Barbara Museum of Natural History)

Hudson, Travis and Ernest Underhay
1978 *Crystals in the Sky: An Intellectual Odyssey Involving Chumash Astronomy, Cos-
 mology and Rock Art* (Socorro: Ballena Press)

James, Harry C.
1960 *The Cahuilla Indians* (Los Angeles: Westernlore Press)

Jenkins, Laverna
1999 Interview with Laverna Jenkins by Brian Bibby, September 9. Audiotape and
 transcript on file at Marin Museum of the American Indian, Novato

Karp, Harvey M.D.
2002 *The Happiest Baby on the Block: The New Way to Calm Crying and Help Your Baby
 Sleep Longer* (New York: Bantam)

Kelly, Isabel T.
1932 *Ethnography of the Surprise Valley Paiute.* University of California Publications in
 American Archaeology and Ethnology 31(3) (Berkeley, University of California
 Press)

Kingery, J. B.
2003 Personal communication with Brian Bibby

Kizer, Marie
2001 Interview with Marie Kizer by Brian Bibby, May 4. Transcript on file at Marin
 Musuem of the American Indian, Novato

Kroeber, A. L.

1925 *Handbook of the Indians of California.* Bureau of American Ethnology Bulletin 78 (Washington, D.C.: Government Printing Office). Reprint New York: Dover Publications, 1976

1932 *The Patwin and Their Neighbors.* University of California Publications in American Archaeology and Ethnology 29(4) (Berkeley: University of California Press)

Kroeber, A. L. and E. W. Gifford

1980 *Karok Myths* (Berkeley: University of California Press)

Latta, Frank F.

1936 *California Indian Folklore* (Shafter, Calif.: F. F. Latta)

1977 *Handbook of Yokuts Indians* (Santa Cruz, Calif.: Bear State Books)

Lee, Gaylen

2003 Interview with Gaylen Lee by Terry Strauss, December 2. Video on file at Marin Museum of the American Indian, Novato.

1998 *Walking Where We Lived: Memoirs of a Mono Indian Family* (Norman: University of Oklahoma Press)

Librado, Fernando

1977 *The Eye of the Flute: Chumash Traditional History and Ritual as Told by Fernando Librado Kitsepawit to John P. Harrington* (Santa Barbara: Santa Barbara Museum of Natural History)

Loeb, Edwin

1926 *Pomo Folkways.* University of California Publications in American Archaeology and Ethnology, 19 (2) (Berkeley: University of California Press)

1932 *The Western Kuksu Cult.* University of California Publications in American Archaeology and Ethnology 33(1) (Berkeley: University of California Press)

Longinos, José Martínez

1961 *Journal: Notes and Observations of the Naturalist of the Botanical Expedition in New and Old California and the South Coast, 1791–1792,* Lesley Byrd Simpson, ed. and trans. (San Francisco: J. Howell Books, and Santa Barbara Historical Society)

Luomala, Katharine

1978 "Tipai-Ipai." In *Handbook of North American Indians,* William C. Sturtevant, gen. ed., vol. 8 (Washington, D.C.: Smithsonian Institution)

Marwitt, John P.

1986 "Fremont Cultures." In *Handbook of the North American Indians,* William C. Sturtevant, gen. ed., vol. 11 (Washington, D.C.: Smithsonian Institution)

Mason, Otis T.

1889 "Cradles of the American Aborigines." In *Report of the U.S. National Museum 1886–87* (Washington: Government Printing Office)

Merriam, C. Hart
1910 *The Dawn of the World: Myths and Weird Tales Told by the Mewan Indians of California* (Cleveland: Arthur H. Clarke)

Morris, Earl H. and Robert F. Burgh
1941 *Anasazi Basketry: Basket Maker II Through Pueblo III, A Study Based on Specimens from the San Juan River Country* (Washington, D.C.: Carnegie Institution of Washington)

Murillo, Pauline
2004 Personal communication with Brian Bibby

Noonan, Michelle
2001 Personal communication with Brian Bibby

O'Neale, Lila M.
1932 *Yurok-Karok Basket Weavers,* University of California Publications in American Archaeology and Ethnology 32(1) (Berkeley: University of California Press)

Oswalt, Robert L.
1964 *Kashaya Texts.* University of California Publications in Linguistics 36. (Berkeley and Los Angeles: University of California Press)

Pacific Western Traders
1978 *California Tribal Arts* (Folsom, Calif.: Pacific Western Traders)

Park, Susan
1986 *Samson Grant, Atsuge Shaman* (Redding, Calif.: Redding Museum and Art Center)

Peck, Ennis
1999 Personal communication with Brian Bibby, September 8

Polanich, Judith K.
1995 "The Origins of Western Mono Coiled Basketry: A Reconstruction of Prehistoric Change in Material Culture." *Museum Anthropology* 19(3):58–68.

Pomona, Ruby
2003 Interview with Ruby Pomona by Terry Strauss, December 2. Video on file at Marin Museum of the American Indian, Novato

Powers, Stephen
1877 *Tribes of California.* Contributions to North American Ethnology III (Washington: Department of the Interior, U.S. Geographical and Geological Survey of the Rocky Mountain Region, Government Printing Office)

Price, John A.

1963 In Barrett, S. A., *The Washo Indians of California and Nevada,* Warren L. d'Azevedo, ed., University of Utah Anthropological Papers 67 (Salt Lake City: University of Utah Press)

1980 *The Washo Indians: History, Life Cycle, Religion, Technology, Economy, and Modern Life.* Nevada State Museum Occasional Papers 4 (Carson City, Nev.: Nevada State Museum)

Priestly, H. I.

1937 *A Historical, Political and Natural Description of California by Pedro Fages* (Berkeley: University of California Press)

Ramon, Dorothy and Eric Elliot

2000 *Wayta Yawa: Always Believe* (Banning, Calif.: Malki Museum Press)

Rathbun, Robert (Coyote Man)

1973 *Destruction of the People* (Berkeley: Brother William Press)

Sapir, Edward

1910 *Yana Texts.* University of California Publications in American Archaeology and Ethnology 9(1) (Berkeley: University of California Press)

Sapir, Edward, and Leslie Spier

1943 *Notes on the Culture of the Yana.* University of California Anthropological Records 3(3) (Berkeley: University of California Press)

Sendldorfer, Leona McCoy

2001 Letter to Brian Bibby, September 13

Sherman, Francys

1999 Interview with Francys Sherman by Brian Bibby, May 11. Audiotape and transcript on file at Marin Museum of the American Indian, Novato

Shipek, Florence

1970 Shipek, Florence, *The Autobiography of Delfina Cuero, a Diegueño Indian* (Banning, Calif.: Malki Museum Press)

Smith-Ferri, Sherrie

2000 Personal communication with Brian Bibby

Stanley, Dorothy

1972 Personal communication with Craig D. Bates

Steward, Julian H.

1933 *Ethnography of the Owens Valley Paiute,* University of California Publications in American Archaeology and Ethnology 33(3) (Berkeley: University of California Press)

Strong, William D.

1929 *Aboriginal Society in Southern California.* University of California Publications in American Archaeology and Ethnology 26(1) (Berkeley: University of California Press)

Taber, Cornelia

1911 *California and Her Indian Children* (San Jose: The Northern California Indian Association)

Walker, Lena

1974 Personal communication with Craig D. Bates, 1974

Waterman, Thomas T.

1910 *The Religious Practices of the Diegueño Indians.* University of California Publications in American Archaeology and Ethnology 8(6) (Berkeley: University of California Press)

Wessell, Viola

1970 Personal communication with Craig D. Bates

Wheat, Margaret M.

1967 *Survival Arts of the Primitive Paiutes* (Reno: University of Nevada Press)

Woiche, Istet (William Hulsey)

1928 *An-Nik-A-Del: The History of the Universe as Told by the Mo-des-se Indians of California,* C. Hart Merriam, ed. (Boston: The Stratford Company). Reprint 1992, University of Arizona Press

Yamane, Linda

2000 Personal communication with Craig D. Bates

Zigmond, Maurice

1980 *Kawaiisu Mythology: An Oral Tradition of South-Central California,* Ballena Press Anthropological Papers 18 (Menlo Park: Ballena Press)